THE HOUSE

OF

THE SEVEN GABLES,

AN EXHIBITION CATALOGUE.

BY

KENDRA PAITZ,

WITH

JUSTINE S. MURISON, CHRISTOPHER ATKINS, AND CORINNE MAY BOTZ.

NORMAL, ILLINOIS:
UNIVERSITY GALLERIES OF ILLINOIS STATE UNIVERSITY.

MMXIV

Now, see: under those seven gables, at which we now look up—and which old Colonel Pyncheon meant to be the house of his descendants, in prosperity and happiness, down to an epoch far beyond the present—under that roof, through a portion of three centuries, there has been perpetual remorse of conscience, a constantly defeated hope, strife amongst kindred, various misery, a strange form of death, dark suspicion, unspeakable disgrace—all or most of which calamity I have the means of tracing to the old Puritan's inordinate desire to plant and endow a family. To plant a family!

—Nathaniel Hawthorne, *The House of the Seven Gables*, 1851, 211-212.

CONTENTS.

 Page

I.—Justine S. Murison, *Art, History, And Haunted Houses: Nathaniel Hawthorne's The House Of The Seven Gables* 5

II.—Kendra Paitz, *We Live In Dead Men's Houses* 11

III.—Artworks . 30

IV.—Exhibition Views . 86

V.—Corinne May Botz, Excerpts From *The House Remembers* 96

VI.—Christopher Atkins, *Shall We Never, Never Get Rid Of This Past?* 99

VII.—Synopsis Of Major Characters 106

VIII.—Acknowledgements . 108

IX.—Events . 110

X.—Credits . 111

THE HOUSE
OF
THE SEVEN GABLES.

I.

ART, HISTORY, AND HAUNTED HOUSES: NATHANIEL HAWTHORNE'S *THE HOUSE OF THE SEVEN GABLES.*

IN THE dark recesses of the titular house in Nathaniel Hawthorne's *The House of the Seven Gables* (1851) hangs a peculiar portrait of the Pyncheon family's Puritan ancestor. This portrait, as it turns out, is vitally important to the plot of Hawthorne's novel. Behind it hides a family mystery: the missing deeds to the Maine land that two centuries of descendants have desperately tried to prove they own. In one of many descriptions of this portrait, Hawthorne's narrator notes that the figure in the portrait has "faded into the canvas, and hidden itself behind the duskiness of age" but also, paradoxically, grown more prominent:

> For, while the physical outline and substance were darkening away from the beholder's eye, the bold, hard, and, at the same time, indirect character of the man seemed to be brought out in a kind of spiritual relief. Such an effect may occasionally be observed in pictures of antique date. They acquire a look which an artist (if he have anything like the complacency of artists, now-a-days) would never dream of presenting to a patron as his own characteristic expression, but which, nevertheless, we at once recognize as reflecting the unlovely truth of a human soul.[1]

To our postmodern ears, the claim that a portrait can reveal the "unlovely truth of a human soul" itself sounds antiquated. If we follow the line of thinking of both Frederic Jameson and Jean Baudrillard, we do not find truth or reality in painting, but a swirl of referentiality and representation, fragmentation and surface, a never-ending *representation* with no original *presentation*.

But Hawthorne most certainly means that this portrait, over time, reveals the truth about Colonel Pyncheon, and that truth is, no less, an ugly one. Yet, and this is an important distinction, Hawthorne does not mean the essential fact of Colonel Pyncheon. The modern fact, as Mary Poovey argues, emerged in the seventeenth century in opposition to Aristotelian epistemology and rhetorical conventions. To put it plainly, what we now assume about a "fact"—that it is both a discrete, transparent unit of information and the foundation for general knowledge about the world—Poovey locates as a result of a historical process that began in the late Renaissance and depended upon cordoning off other epistemological modes, deeming them rhetorical, supernatural, or simply unprovable.[2]

Colonel Pyncheon's portrait is a clue to how Hawthorne considers the relation of art to both "truth" and "fact," and more broadly it helps readers understand the genre of *The House of the Seven Gables*. What Hawthorne attempts to capture in his description of the Colonel's portrait is not how art can represent reality (the transparent facts of our everyday world) so much as how art reveals the assumptions and complexities hiding behind the term "reality," assumptions that value certain styles of writing as a mark of realism. His emphasis on "truth" in art is exemplified in his insistence that *The House of the Seven Gables* (like all of his long fiction) be termed a "romance" not a "novel." As he puts it in the preface to *Seven Gables*, a novel "is presumed to aim at a very minute fidelity, not merely to the possible, but to the probable and ordinary course of man's experience," while the romance, though it cannot "swerve aside from the truth of the human heart," allows for a wider latitude of representation. The writer of romance, Hawthorne insists, "may so manage his atmospherical medium as to bring out or mellow the lights and deepen and enrich the shadows of the picture."[3] Quite famously, Hawthorne draws here not on portraiture for his compositional analogy but on the new technique of daguerreotypy. Calling attention to the use of light in the production of his romance, Hawthorne associates *romance* with *photography* in a way that seems counterintuitive to the assumptions about photography as a realistic (and thus, analogically, a factual) medium. But as Susan Williams, Marcy Dinius, and other scholars of the nineteenth-century invention of daguerreotypy remind us, this connection of romance to the daguerreotype was not all that unusual. As Williams puts it, this new art was conceived "simultaneously as a magical agent of revelation, an astoundingly 'true' and accurate likeness, and a locus of sentimental value."[4]

Hawthorne invests the daguerreotype, as he does the aging portrait of Colonel Pyncheon, with an ability to reveal truth about character. As the daguerreotypist of the novel, Holgrave, explains, "There is a wonderful insight in heaven's broad and simple sunshine. While we give credit only for depicting the merest surface, it actually brings out the secret character with a truth that no painter would ever venture upon, even could he detect it."[5] Surface and sunshine, in other words, can betray depths and secrets. No painter, Holgrave suggests, would hazard such a trick and hope to be paid by the sitter, though as we know the portrait will eventually "out" that character nonetheless. The daguerreotypist can ascribe revelations of secret character to the "scientific" aspects of the medium over which he or she has no control; this scientific veneer is really just an alibi, though, allowing the artist to reveal a sitter's personality. Hawthorne, though, does not see a great distinction between painting and daguerreotypy. While the portrait *eventually* brings out the "secret character" of its sitter, a daguerreotype *immediately* does. The distinction between the two mediums is temporal rather than of a kind. In either case, exposure, in time, will out one's character. Art and romance operate together, in other words. In doing so, they demonstrate to viewers that which is haunting the mundane world, that which motivates people beyond what can be seen on the surface.

The development and exposure of secret character is indeed the point of *The House of the Seven Gables*. Rather than a novel of adventure and suspense, Hawthorne concentrates on the delicate interplay between private and public character. *The House of the Seven Gables* narrates the travails of the Pyncheon family of Salem, Massachusetts, from their founding member, a stern Puritan with a penchant for turning witchcraft accusations into real estate opportunities, to the remaining members of the family, the main characters of the novel set in the 1850s Unites States: old Hepzibah, with her misunderstood scowl; her brother and object of affection and care, Clifford, the aesthete recently released from prison for a murder he did not commit; their cousin Phoebe, the angel of the house with New England common sense practicality; and finally, their other cousin Judge Jaffrey Pyncheon, a seeming reincarnation of the seventeenth-century Puritan, but with a "sultry, dog-day" smile adapted to a democratic age. Jaffrey is the villain of the plot: responsible for Clifford's unfair imprisonment, he continues to hound Hepzibah and Clifford with his malevolent intentions. The modern day Pyncheons' power struggle is rooted, the narrative implies, in the house, built on land the old Puritan Colonel Pyncheon has acquired by manipulating witchcraft accusations against Matthew Maule, who, in turn, had cursed Pyncheon ("God will give him blood to drink!"). When Colonel Pyncheon dies unexpectedly on the day of his own house-warming party, with "blood on his ruff," Maule's curse seems to have come true. Hawthorne's romance suggests, without stating explicitly, that a curse can have a real effect on a family.

By invoking a curse, Hawthorne moves outside of strict realism. Doing so, he can represent the immaterial yet real effects of history on the present. This desire to delineate the effects of history in the present is seen most apparently in the gothic genre. From wildly popular eighteenth-century page-turners like Ann Radcliffe's *The Mysteries of Udolpho* (1794) to the familiar nineteenth-century novels of Mary Shelley's *Frankenstein* (1818) and Bram Stoker's *Dracula* (1897) to today's love of *Twilight* and *The Walking Dead*, audiences have long been obsessed with the gothic. The gothic asks us to dwell upon the metaphoric lingering of the dead—and the consequences of the dead's actions on the living. Yet *The House of the Seven Gables* never veers into an explicit affirmation of the gothic mode. Hawthorne's gothic is not quite like the horrors of vampires and zombies. Instead, we might now call it the "fantastic," which, as defined by Tzvetan Todorov, presents the "world of the characters as a world of living persons" but yet obliges the reader "to hesitate between a natural and supernatural explanation of the events described."[6] Hawthorne's contemporary reviewers appreciated how his novel walked this fine line, producing a feeling of real world characters enmeshed in a potentially supernatural curse. While a review of the novel in the May 1851 *Athenaeum* makes Hawthorne "a necromancer," George Ripley, reviewing the novel for Harper's *New Monthly Magazine*, opines, "In spite of the supernatural drapery in which they are enveloped," the characters "have such a genuine

expression of flesh and blood, that we can not doubt we have known them all our days. They have the air of old acquaintance—only we wonder how the artist got them to sit for their likenesses."[7] Conflating Hawthorne with Holgrave, his daguerreotypist, Ripley ultimately suggests that Hawthorne's romance is one that can, through art, bring out some semblance of the real without resorting to realism.

What is it that Hawthorne ultimately seeks to show through such a genre choice? *The House of the Seven Gable*s narrates how seemingly everyday decisions about the building of a house, say, involve people in great moral hazards. In other words, the haunting in the novel traces the material effects of something we might deem immaterial—the past. Hawthorne may well have anticipated that very trenchant observation of William Faulkner in *Requiem for a Nun* (1950) that "[t]he past is never dead. It's not even past." Hawthorne's way of expressing this living past is metaphorically and literally to place at the center of his plot a corpse. Or, to be more exact, at the center of both the plot and the titular house of the novel, sit two corpses, both alike—one the descendant of the other. Both Colonel Pyncheon and Jaffrey Pyncheon die in the same way and in the same place in the house, and Hawthorne relentlessly ties the two villains (one a Puritan, the other a democrat of the modern era) together. The culmination of their hunger for power and land is this haunted house, which means, for instance, that Clifford Pyncheon's release from prison merely brings him back to a living death in the house. Thus the haunted house has its greatest impact on the character who has suffered the most for the Pyncheon curse: Clifford has spent his whole life in prison because Jaffrey Pyncheon, jealous that Clifford will inherit the family wealth, hid crucial information about Clifford's innocence. In his one taste of freedom from the house, Clifford muses to a "gimlet-eyed" stranger, "Now, Sir," he explains:

> whenever my thoughts recur to this seven-gabled mansion—(the fact is so very curious that I must needs mention it)—immediately, I have a vision or image of an elderly man, of remarkably stern countenance, sitting in an oaken elbow-chair, dead, stone-dead, with an ugly flow of blood upon his shirt-bosom. Dead, but with open eyes! He taints the whole house, as I remember it.[8]

Clifford's desire to run from the domestic space is spurred by the dawning realization that it is the house itself that is haunted with (in this case) a literal corpse sitting in the study. Rocked by the railcar, Clifford imagines that perhaps all domestic spaces contain a haunted center, a corpse that taints the atmosphere. History and the weight of ancestors—symbolized by Jaffrey Pyncheon's corpse—suffocate the current inhabitants, making it impossible to find freedom.

Clifford's emphasis on "countenance" calls our attention again to Hawthorne's recurrence to artistic representation throughout the novel and brings us back to the problem of art and truth with which this essay began. While Jaffrey Pyncheon's corpse remains in the study, he is watched by the painting of Colonel Pyncheon, whose

will had mandated that the portrait never be taken down. That painting, as the quotation with which I began indicates, has, over time, revealed the "truth" of its stern sitter but perhaps not the facts that have driven successive Pyncheons crazy: what happened to the deeds to the Maine lands? Insisting on memorializing himself, Pyncheon has inadvertently prompted the greatest poetic justice of the novel. Matthew Maule's son built the House of the Seven Gables for the Colonel, and, while completing its construction, hid the most important real estate deeds the family holds behind the portrait. In other words, the mundane facts of the world of law and property hide behind the portrait, and they are only revealed when Holgrave, a descendant of the Maules and now betrothed to Phoebe Pyncheon, presses the spring and reveals the documents hidden within. In essence, Hawthorne ultimately inverts the trope of surface and depth with this revelation. While the painting mellows into a revelation of truth that is discernible on the surface and is what everyone who visits the house sees, the "surface" facts of the world are hidden deep behind the painting. In this case, the "ugly truth" about the Puritan ancestor hides the facts of the world, a fitting retribution for his villainy.

More importantly, though, these facts are at the mercy of the artist and the artisan. The chapter in which the narrator speaks to the corpse of Jaffrey Pyncheon shows us this fine line between the fact of the deeds and the truth of art. This chapter is all exposition. The narrator chides the corpse for missing his meetings, for failing to see that his watch has stopped, and for not noticing—perhaps—that the ghosts of Pyncheons past have gathered around him to cajole him to take down Colonel Pyncheon's portrait. At just the point when a reader may be ready to plunge fully into a gothic mode, interpreting these invocations by ghostly ancestors as facts of the plot, Hawthorne's narrator recovers the indeterminacy of the fantastic:

> 'The fantastic scene, just hinted at,' the narrator admits, 'must by no means be considered as forming an actual portion of our story. We were betrayed into this brief extravagance by the quiver of the moonbeams; they dance hand-in-hand with shadows, and are reflected in the looking-glass, which, you are aware, is always a kind of window or door-way into the spiritual world.'[9]

But does this mean the reader ought to dismiss the "fantastic scene"? No, because to do so would be to decide that history has no weight and no presence in the present day, and the thrust of the narrative asks the reader to take seriously that weight. The reader must be willing to be enchanted by the haunted history hinted at throughout the story, but also to see that it is not a fact of the world as such.

The historic haunting throughout the novel eases into a more typical romance (the cross-class marriage of Phoebe and Holgrave) by the conclusion, and Hawthorne can only enact this finale by the abandonment of the house itself. Inheriting the country property from Jaffrey Pyncheon, Hepzibah, Clifford, Phoebe, and Holgrave move out of the tainted mansion just as any heroes and heroines might flee a haunted castle. In a way, Holgrave

has freed the Pyncheons by both showing them where the Maine deeds are and, as the narrator makes clear, also pointing out that there would be no way for them ever to recover the land nonetheless. The Pyncheons must give up this dream of more land, and the final remnants of the line do just that. Solving the mystery of the Maine deeds, they can come to represent the aspirations of a middle class, never haunted by the past and certainly not constrained by it. Yet Hawthorne cannot quite end there. The final paragraph of the novel reinvokes a fantastic element, suggesting that Maule's Well (the only standing structure left from that original owner) had "thrown love's web of sorcery" over Phoebe and Holgrave.[10] Another character, Uncle Venner, hears one of the old Pyncheon ancestors, Alice, strike a final note on her harpsichord and ascend to heaven, finally released from the haunted house. In this way, Hawthorne still reasserts the romance of history in the final paragraph, with characters enacting the results of century-long desires and curses. Hawthorne thus offers us an optimistic ending, to be sure, but one that will not let readers forget how the "legendary mist" of the past can still shadow the "broad daylight" of our everyday lives.[11]

—Justine S. Murison is Associate Professor of English at the University of Illinois at Urbana-Champaign.

1. Nathaniel Hawthorne, *The House of the Seven Gables* (New York: Penguin, 1986), 59.
2. Mary Poovey, *A History of the Modern Fact: Problems of Knowledge in the Sciences of Wealth and Society* (University of Chicago Press, 1998), 7-9, 93.
3. Hawthorne, 1.
4. Susan Williams, *Confounding Images: Photography and Portraiture in Antebellum American Fiction* (Philadelphia: University of Pennsylvania Press, 1997), 3. See also Dinius, chapter 2.
5. Hawthorne, 91.
6. Tzetvan Todorov, *The Fantastic: A Structural Approach to a Literary Genre* (Ithaca, NY: Cornell University Press, 1975), 33.
7. [Henry Fothergill Chorley], "The House of the Seven Gables" in *Nathaniel Hawthorne: The Contemporary Reviews*, eds. John L. Idol, Jr. and Buford Jones (Cambridge University Press, 1994), 164-166: 165; [George Ripley], "The House of the Seven Gables" in *Nathaniel Hawthorne: The Contemporary Reviews*, 167-168: 167.
8. Hawthorne, 261.
9. Hawthorne, 281.
10. Hawthorne, 319.
11. Hawthorne, 2.

II.

WE LIVE IN DEAD MEN'S HOUSES.

NATHANIEL Hawthorne's *The House of the Seven Gables* was first published in 1851, three years after the beginning of the Spiritualist movement in the United States and ten years before the start of the American Civil War. Writing at a time when a nation under the influence of its Puritan origins was still forming its identity, Hawthorne was exploring the social ramifications of emerging classes and questioning the role of both the past and religion in determining a national consciousness. Written concurrently with the rise of daguerreotype photography—and notably featuring an ever-watchful oil portrait, a fetishized miniature portrait, and daguerreotypes made by a central character—the modes of representation Hawthorne references not only become increasingly more modern and available to the mass culture as the book progresses, but also reveal "hidden truths" about the characters.[1] The author's intentions, according to historian Alan Trachtenberg, were to "probe the new implications of the new order of things of which photography serves as the auspicious type."[2] For Hawthorne, photography was a useful barometer not only for measuring social and economic change, but also for scrutinizing and exploiting 19th century fears of the unknown that linked scientific technology with magic and witchcraft. For example, the daguerreotypist, Holgrave, a democratic artist who ushers in truth and modernity, is also a mesmerist with a bewitching ancestry.[3] Traces of the supernatural recur throughout the narrative and the flitting image haunting a daguerreotype's mirrored surface reflects both the rational and the fantastic, what can be seen and what remains mysterious.

The horror of the 1692 Salem Witch Trials is the original specter that haunts *The House of the Seven Gables*. At the outset of the book, Colonel Pyncheon, the Puritan patriarch of the Pyncheon family, accuses Matthew Maule, the patriarch of the Maule family, of practicing wizardry, for which the latter is ultimately executed. As he is about to be hanged, Maule points to Pyncheon and places a curse upon his family, declaring "God will give him blood to drink."[4] Pyncheon then perversely builds his magnificent House of the Seven Gables over the "unquiet grave" of the dead man.[5] This particular course of events ignites the multi-generational trauma experienced by the novel's characters, but also refers to the guilt Hawthorne suffered over the role his forebears played in enforcing the Puritan code.[6] As historian Enders Robinson writes, "Major William Hathorne persecuted the Quakers; magistrate John Hathorne persecuted the accused witches."[7] Robinson goes so far as to name John Hathorne, Hawthorne's great-great-grandfather, as "the chief witch hunter."[8] Hawthorne's ancestral guilt seeps through to such a degree in his book's references to a curse, an unjust hanging, and a corrupt judge, that the tale seems to double as his personal exorcism.

Hawthorne was not alone in his authorial references to pernicious family dynamics. Historian Richard Davenport-Hines points out that in response to increasingly radical adoration of family, many American writers "adapted gothic imagery to exemplify the destructive power of families."[9] Historian and architecture critic Anthony Vidler explains the direction writers exploring this topic often followed:

> By far the most popular topos of the nineteenth-century uncanny was the haunted house.... The house provided an especially favored site for uncanny disturbances: its apparent domesticity, its residue of family history and nostalgia, its role as the last and most intimate shelter of private comfort sharpened by contrast the terror of invasion by alien spirits.[10]

Hawthorne imagined the quintessential haunted house in his titular mansion, complete with gothic exterior and an interior rife with the residue of successive generations of violence, superstition, anxiety, and inherited guilt. Serving as a repository of memory, the house itself functions as a melancholic portrait of the family's collective trauma. Hawthorne's use of architecture and daguerreotype portraiture as devices to explore a haunting of the present by the past resonates beyond his time. The house, for instance, is now a common emblem for haunting, traumatic histories, and even nostalgia, not only in literature, but also in poetry, art, film, and television. In his influential book, *The Poetics of Space*, Gaston Bachelard offers an exquisite rationale: "A house constitutes a body of images that give mankind proofs or illusions of stability. We are constantly re-imagining its reality: to distinguish all these images would be to describe the soul of the house; it would mean developing a veritable psychology of the house."[11]

Although he wrote *The House of the Seven Gables* nearly seventy years before Sigmund Freud published *The Uncanny*, Hawthorne's various ploys—including repression of memories (how the land was acquired, Jaffrey Pyncheon's murder, and the existence of the secret spring on the portrait's frame); doubling of characters across generations (including Colonel Pyncheon/Judge Pyncheon and Alice/Phoebe); and conflation of the strange and familiar—render instances of the uncanny throughout the narrative. Freud identifies the uncanny as "that species of the frightening that goes back to what was once well known and had long been familiar."[12] He cites Thomas Schelling's definition of the uncanny as "something that should have remained hidden and has come into the open."[13] Colonel Pyncheon's devious accusation of Matthew Maule in order to steal his land was certainly repressed by ensuing generations. As Trachtenberg states:

> [The truth] lies in his history, a family history of illegitimate class privilege and abrogated power, and particularly the use of established authority to lend an official seal to the original theft of Maule's land. It is in the Pyncheon interest to keep that origin secret, to repress its threatening truth, and when repression becomes habitual, it produces a secretiveness that no longer understands what it hides or why.[14]

How and why property is acquired and what it indicates about society's acceptance of greed

and corruption are central ideas to understanding the national history that Hawthorne was attempting to reconcile. His discussion of usurping land can be extrapolated beyond the fictional Pyncheon/Maule fiasco to the real-life colonization of the United States. Just like the Colonel's portrait, a map hangs on the wall of the seven-gabled house, reinforcing an illusion of extreme wealth to generations of Pyncheons. They believe they will actually acquire abundant "Maine lands" if they are able to find the mysterious "Indian deed" that was lost by their forefather.

As a contemporary response to both Hawthorne's realization of the metaphoric possibilities inherent in representations such as deeds, maps, paintings, and photographs, and his incredibly vivid, almost cinematic, language, this exhibition began as an approach to interpreting literature through the lens of artworks being made today. The connections were ripe for exploring: both literature and art allow for imaginary worlds, complexities, symbolism, hidden meanings, contemplation, and tapping into the unconscious. And as Trachtenberg writes about Hawthorne's book: "The question of visuality as cognition lies athwart the entire narrative."[15] An encapsulation of the unhomely permeates the works in the exhibition, and those with connections to a family home are suffused with a sense of loss and decay. Architectural, decorative, and functional elements that one might find in a house at the time Hawthorne was writing are repeated throughout the exhibition, and the manner in which the artists treat and present these materials often renders an uncanny experience for the viewer. Additionally, because Hawthorne so heavily incorporated the emerging technology of photography into his tale—engaging (at the time) a startling dialogue on the hidden "truths" a daguerreotype could reveal—slightly more than half of the works in the exhibition comment on photographic or filmic vision.

It is important to note that my curatorial scope was not limited to works with direct references to Hawthorne. There are actually three categories of artwork in the exhibition: those that were not created with Hawthorne in mind but that, for me, bear a relation to the author's themes, strategies, and writing style; those not made for this exhibition but directly inspired by either Hawthorne's works or Puritan New England, such as Sue de Beer's *The Quickening* or Rachel Feinstein's *Puritan's Delight*; and lastly, those created specifically for this project, including Benjamin Gardner's *thy hope forgiving* and Corinne May Botz's *Ink Stain (Nathaniel Hawthorne's Desk)* and *Rebecca Nurse Homestead*. My idea extended beyond the exhibition to this catalogue, which was designed to visually reference the first edition of *The House of the Seven Gables*. While this project neither represents a conclusive interpretation of Hawthorne's book—theoretically, aesthetically, or otherwise—nor a thesis on the relationship between art and literature, it is my attempt to use a canonical work of early American literature as the conceptual impetus for curating an exhibition of contemporary artworks that, to me, both manifest the author's themes and literary strategies, and reveal a continued collective fascination with the haunting of the present by the past.

In his preface to *The House of the Seven Gables*, Hawthorne writes, "The point of view in which this Tale comes under the Romantic definition, lies in the attempt to connect a by-gone time with the very Present that is flitting away from us."[16] Consistent with his motifs, the artworks included in the exhibition reflect variously on the passage of time—particularly how the residue of family history manifests itself—and aspects of anxiety, memory, and ruin. The artists earnestly delve into the themes of haunting, photography, and the architectural uncanny inherent in Hawthorne's supernaturally-tinged reconciliation of the foregone with the contemporary.

Corinne May Botz confronted the tainted history of Salem, Massachusetts, when she traveled there to make two new photographs for the exhibition, *Ink Stain (Nathaniel Hawthorne's Desk)* (2012) and *Rebecca Nurse Homestead* (2012). For the former, Botz captured through her lens an ink stain on the wooden desk at which Hawthorne wrote *The House of the Seven Gables*. The spiraling, hexagonal spill still seems remarkably fresh on the aged wood. Her closely cropped forensic-like image resonates with the celebrated author's physical trace as well as a notion of stained histories, both fictional and real: the Pyncheon curse and Hawthorne's progenitor's role in the Trials. Hawthorne's desk now resides in The House of the Seven Gables, a tourist site dedicated to a house previously owned by one of Hawthorne's relatives and rumored to have inspired the book's seven-gabled mansion. For Botz's photographic series, *Haunted Houses*, the artist traveled throughout the United States documenting the interiors of reputedly haunted domestic spaces. Her encounter with Hawthorne's past demonstrates a haunting of another type, that of an influential author on subsequent generations of writers. With few existing photographs of Hawthorne himself (including a portrait by Mathew Brady), Botz provides a poignant Barthesian "that has been" moment.[17]

For *Rebecca Nurse Homestead*, Botz visited another tourist site, the home of Rebecca Nurse, a 71-year old great-grandmother who was hanged on July 19, 1692, as a result of the witch hysteria in Salem.[18] A portion of a scarred door fills the entire frame of the photograph, its marks and mars showing the ravages of time. The image transports the viewer directly to the portal between Nurse's private realm and the public world. As in a novel or film, the knotted rope door handle that Nurse would have pulled on—and that Botz shows hanging limply on the left side of the image—might have foreshadowed the innocent woman's demise on the gallows. Botz recovers a bit of Nurse's biography, quietly presenting it without sensationalism—in fact, one would need to read the title to connect the image to the historical figure—and reminding a viewer that Nurse was not a character but an actual person who would have walked through this architectural feature.[19]

In Sue de Beer's *The Quickening* (2006), a video set in Puritan New England, the horror film functions as an updated version of the gothic romance. De Beer was raised in and around Salem, and the imagery and text that she incorporates evoke the spiritual

tension and resulting violence that are foundational to *The House of the Seven Gables*. The "imprint of Puritan sermons is etched clearly on the novel's pages," according to Marilyn Chandler, who cites the particular influence of Jonathan Edwards's "Sinners in the Hands of an Angry God" sermon on Hawthorne.[20] Meanwhile, in de Beer's video, a brutal series of scenes in which a woman is stabbed by an unknown assailant and hanged from a noose in the moonlight is followed by plain text announcing a shift to "Enfield, Connecticut, 1741," the site of Edwards's second delivery of his influential address. As the soundtrack's voice sermonizes about "wicked unbelievers," several sepia toned images of Salem's House of the Seven Gables appear in slow succession on the screen. The artist's interweaving of monologues by Edwards and Joris-Karl Huysman into the fragmented narrative recalls Hawthorne's narrator's use of allegories, hearsay and rumor.[21]

In keeping with gothic distinctions between the rational and irrational, there is a fascinating slippage between the narrative's actuality and fantasy in both Hawthorne's book and de Beer's video. For example, in the book, ghosts of deceased Pyncheon family members gather in the Colonel's study to search for the missing deed, while in the video, a female protagonist dressed in a provocative modern version of Puritan attire dances in a meadow with a costumed wolf and bull. The intense thumping "heartbeat" in de Beer's soundtrack evokes Hawthorne's personification of the house: "[T]he very timbers were oozy, as with the moisture of a heart. It was itself like a great human heart, with a life of its own, and full of rich and sombre reminiscences."[22] The revelation of secrets offers a particularly striking parallel between Hawthorne's and de Beer's works. While studying drawings and reading a letter, a female character in *The Quickening* discovers a mysterious message: "the key to the secret is hidden in a picture and the name of a person living in the house." In *The House of the Seven Gables*, the long-missing and sought-after deed is revealed to have been hidden in the frame of Colonel Pyncheon's portrait, placed there by a Maule, one of whom still resides within the walls of the old house.

Like de Beer, Rachel Feinstein references America's spiritual past in her large sculpture *Puritan's Delight* (2008). A former religion major, Feinstein says that she has "always taken an interest in the violent, decadent side of religion,"[23] and she often references historical, sacred, and mythological iconography in her work. Devoid of human occupants or horses, the artist's distorted and disembodied carriage appears to be the site of a tragic accident and resulting memorial. An uncomfortable void looms within the stilted vehicle's rounded body, and an eternal flame in the form of an electric light bulb casts a soft glow across the graphic lines of the folded wheels and three erect crosses. Like the Pyncheon family, the carriage is in a state of stasis rather than forward trajectory. Having reached a "dead-end," it is ruined and non-functioning but the light burns on—echoing Chandler's statement about Hawthorne's fictional house in *Dwelling in the Text: Houses in American Fiction*: "The outline of Christian salvation history is reiterated in the house's story, from

original sin to the moment of redemption."[24] Although this confrontation with mortality may cause dread for many, it would represent delight for a Puritan.

Bill Conger's *Endless Night* (2006) also draws on the notion of continually burning candles, except his freestanding stack of white tapers is inextinguishable precisely because it has never been lit. Held together with masking tape and magically standing upright, no streams of wax pour down the sides of the composite candle or puddle on the floor; it is in constant limbo waiting to fulfill its intended luminary destiny. Deliberately ramshackle and frail (in fact, the sculpture purposely collects dirt and dust each time it is exhibited), in the context of this exhibition, the work offers a piteous reminder of the continual darkness faced by generations of the Pyncheon family who are plagued with ceaseless loops of rumination. Conger transforms familiar items into meditations on despair befitting a gothic romance. Primarily comprised of altered found objects with poetic titles steeped in literary and musical references, Conger's works offer quiet homages to the seemingly disparate histories of Duchamp's readymades and Proust's notions of memory.[25]

Bob Jones alters everyday materials found in his home, yard, or garage through unexpected combinations, treatments, and titles. In *Father's Headdress* (2006), made shortly after his father's death, Jones, like Hawthorne, draws attention to familial structures and generational shifts. The small black sculpture resting on the floor may initially appear unassuming, but by pairing the work's title and its primary material, hydraulic cement, the weight of the artist's gesture quickly becomes apparent. The concrete sculpture addresses the burden of ancestral acts while its conical black shape recalls the vernacular iconography of the witch's pointed black hat. The slight ripples and fissures on the hand-worked surface speak to a laborious effort to corral dense material into the desired shape. Ever in search of the mythical, Jones revels in transforming the ordinary—whether straw, sticks, cardboard, or, in this case, spray paint and cement—into the unaestheticized marvelous.

Drew Conrad also incorporates found materials into his sculptural works—often combining them with new ones that he distresses—to create architectural "ruins" that tread a critical line toward nostalgia. His *Remnant no. 3 (Chelsea Hotel)* (2012) addresses the deterioration and decay of an architectural space; specks of rust and dust permeate a section of lath broken free from its original building. Recalling Gordon Matta-Clark's "building cuts," Conrad's work functions as a fragment as described by Anthony Vidler in *Warped Space*. A fragment "demands a particular scale; whether small or vast" and "demands a context, a possibly and easily visualized site from which one might imagine it was initially snatched, and to which it might, just as easily, be envisioned as returning."[26] The artist's incorporation of "Chelsea Hotel" in his title implicates an architectural space with its own storied history, a building impregnated with decades of sordid rumors, lurid exchanges, violent encounters and creative interplay among its famous residents, including Jimi Hendrix, Sid Vicious, Nico, Willem de Kooning, and Dylan Thomas. His reference

to an iconic building brings to mind the many creative lives that have not only wandered its halls, but also witnessed its secrets. Paralleling Hawthorne's ideas of secrets buried within the walls of the house, a small frame tucked among the artwork's wooden slats encases a cascading pile of rust and a Polaroid whose image has all but faded into obscurity. Conrad's incorporation of the nearly anachronistic Polaroid reminds the viewer that photographic mediums—writing with light, so to speak—have been under a constant state of transformation since the advent of the daguerreotype about which Hawthorne writes so much.

Robert Overby's *Two Window Wall Map* (20 August 1972) provides a different point of departure for discussing architecture and photographic language. A stitched canvas map of a wall, this ghostly trace of a building not only serves as an index of the placement of the windows and molding but also of the time the artist spent making measurements and stitches.[27] The sewn map "slows" the photographic relationship inherent in Overby's latex rubber casts of actual buildings and architectural fragments, while still capturing or freezing a moment.[28] For more than 40 years, the semi-monumental canvas has been collecting folds, dust, and traces. As an accumulation of residue akin to the seven-gabled house's oozy timbers, Overby's works "were for him most meaningful in terms of how they stood still yet were transformed over time: wear, use, decay, destruction, disappearance."[29] As in a photograph, one cannot access the referent's physical space, but from this work, the viewer can imagine the room to which it refers and project personal reminiscences onto the conjured space.[30] Given Hawthorne's comparison of the mansion's exterior to a "human countenance" in the fourth sentence of the book, it is difficult to resist associating the twin windows with a set of eyes.[31]

The perforated black plastic forming Sarah E. Wood's *Window Shadow* (2008) cascades down the wall and spills across the floor in a manner reminiscent of Robert Morris's felt pieces from the late 1960s. In keeping with her other elegant sculptures of distorted geometric forms, and vaguely recalling a spider web, Wood's work stretches and is pulled down by its own weight. Forming a sagging grid that allows light to punctuate its surface, the mesh not only recalls the material that screens household windows but also conjures up the shifting shadows cast by the sun throughout the course of a day. Wood's representation of a shadow casts its own host of shadows, an ontological play that echoes Hawthorne's use of light and shadow for describing settings and metaphorically disclosing the nature of a character's intentions. Additionally, windows recur throughout *The House of the Seven Gables* as passageways between the family's isolated experience within the house and the ever-more-modern town they observe growing around them.

Benjamin Gardner's *mesmerism and 16 lights #9 (or, the transformation)* (2012) uses a 4 x 4 window structure ("sixteen lights") as its compositional core. Beyond its obvious architectural connotations, this work also refers to the tradition of painting as a "window unto the world." Equally influenced by the histories of painting, craft and folk

art, the artist's hand is always visible in his loose geometric abstractions. Gardner conflates multiple literary references in this one work. His use of the word "mesmerism," so integral to Hawthorne's description of the Maule family's powers, connects to the artist's primary interests in superstition, divination, and folklore, while also nodding to Poe's and Charles Dickens's fascination with animal magnetism.[32] The bewitching hypnosis implied by the word relates to the viewer's visual experience of Gardner's painting; the longer one looks, the more he falls into the palimpsest of imagery. Surrounded by fractured and swirling darkness rendered in thick black paint, the gridded window radiates a cool, uninviting light that may leave the viewer questioning whether he might be looking inward or outward. Thin washes of ink and acrylic are overlaid with a pencil scrawling of the mysterious phrase, "Or, the transformation," a portion of Charles Brockden Brown's title for his 1798 novel, *Weiland: or, The Transformation: An American Tale*, often cited as the first American gothic novel. Gardner identifies the transformations in this work as shifting between "expected and superstitious" as well as "inside to outside."[33]

Transformation and substance as memory are central to understanding Gregor Schneider's process. The psychological weight of the artist's continual construction chronicled in his video *Haus U R, Rheydt, 1985-today* (1996) provides a vital means for exploring anxiety and the uncanny in domestic architectural spaces. This dark, grainy video is Schneider's unnarrated tour of a house that he has been living in and constantly altering since the mid 1980s in his hometown of Rheydt, Germany. The artist has built rooms within rooms, removed walls, and added artificial sunlight and breezes via lamps and fans because some rooms are now so far divorced from the external structure of the house. (The artist's years-long building and modification of a home recalls Sarah Winchester's repetitious 38 years of "spirit-guided" construction of her San Jose, California, home.)[34] Schneider's house was "deemed uninhabitable because of its proximity" to the lead factory where five generations of his family worked.[35] As curator Paul Schimmel describes, the artist "makes plain his belief that the house itself remembers its history—the memories of his grandparents, parents, and his own maturation process, the memories that are the foundation on which *Dead House u r* is built."[36] Schimmel points out that Schneider has hung photographs of his parents and grandmother behind the walls in the layers between rooms.[37] As with the Pyncheon home, the ghosts are consistently resurrected and reburied.

The soundtrack of Schneider's lo-fi video consists of the artist's footsteps, heavy breathing, groans, grunts, and moans as he leads the camera through doorways, up stairs, between walls, and into crawlspaces. The unsettling and disorienting tour leaves one wondering what is lingering in the darkness. As one vicariously navigates the shadowy innards of the structure, he catches fleeting glimpses of the secrets its walls contain: life-size inflatable dolls are the bodies beneath the floorboards; a noose hangs in the center of a cluttered room; a sterile, perfectly set dining room table (the place where a family

gathers to eat, share, laugh, and reminisce) seems to be one of the only finished elements. The artist's body is shown only in fragments—whether a boot, his hand, his hair, or his upper half reflected in a bedroom window, he is a specter in his own house. At one point, Schneider raises an ax in a darkened corridor and we become aware that he is walking through the house wielding a hacking weapon, bringing to mind countless memories of horror movies. As the artist emerges into a small dark space lit exclusively by a glowing globe, one is struck by the profundity that a space so insular and claustrophobic could be illuminated by the light of the whole world.

Like Schneider, Rachel Khedoori creates an uncanny space that relies on the interplay of light and darkness and confounds our notions of interiority and exteriority in her film installation *Ohne Titel (Pink Room)* (2000). A luminous 16mm silent film of a nearly empty room cloaked in aged floral pink wallpaper pours forth from a whirring projector onto a low screen and is reflected in a mirror on the floor of the same dimensions. The darkened gallery is bathed in a soft rosy glow as the dual moving images constantly peel away from each other. In the film, the only view to the vibrant green wilderness beyond the walls comes through twin windows (similar to those in Overby's work). The illusory space Khedoori creates is nearly as disorienting as Schneider's, not only due to the doubled moving room, but because, as in Robert Smithson's work, the mirror also reflects the space surrounding it, with the ceiling appearing on the floor. A viewer's experience shifts based on his position; leaning over the mirror's surface one will also discover his own body repeated as on a daguerreotype. The steady hum of the projector marries with the circling mirrored image to induce a mesmeric effect.

With its floral wallpaper and mirroring of residential space (here, in the surface of a reflective table), Corinne May Botz's photograph *Untitled* (2011) features visual strategies similar to Khedoori's work. Unsettlingly, white plaster crumbles from a dark gaping hole in a household wall onto a table holding antique portraits—perfectly uniting the exhibition's themes of haunting, photography, and the architectural uncanny. One can imagine the hole as a wound, a record of hidden trauma, and the plaster as the secrets spilling forth from a house that, like the fictional home, is haunted by past misdeeds. In a potent link to Judge Pyncheon's transgression, *Untitled*, one of the few photographs the artist has staged, was inspired by historical crime scene records Botz discovered while researching in governmental archives in Washington, D.C. The artist also incorporates re-photographs of beloved black-and-white images from her personal collection into the composition.

As in Botz's photograph, Jacco Olivier's video *Return* (2007) features representations of seemingly treasured vintage photographs. Although only a little over a minute in length, the artist has packed the animation with a host of resonant signifiers for a journey home. Lilting music from a scratchy record issues forth while hand-painted versions of framed family photographs softly arise from their perch and drift into the ether. Suddenly, a train

zips through the countryside—a streak of abstract color accompanied by whooshing and bell ringing—recalling Clifford's and Hepzibah's doomed escape from the house (and the past) on the ultimate symbol of modernity, the locomotive. Like the Pyncheon siblings, the video's point of view returns to a house. Just as the House of the Seven Gables magnetically pulls generations of Pyncheons back under its blackened roof, the looping animation yields endless return trips home. Olivier converges the mediums of painting, photography, video, and animation; given Hawthorne's interest in the relatively new medium of photography, one can only imagine what he would have thought of its contemporary descendant, the digital video.

Although *Portrait* (2009) likewise converges multiple mediums into one digital animation projected in light on the wall, by the time Olivier made this work, he was moving away from the narrative structure of his previous films and engaging more directly with painting. He specifically began exploring traditional themes of portraiture, landscape, and still life. In *Portrait*, a constantly shifting series of painted portraits blurs one into the next as the same t-shirt clad male undergoes changes of mood, lighting, and age, drawing attention to the mutability of both an image and a subject. Early in the video, the man disconcertingly turns his head from a three-quarter profile to a direct gaze at the viewer. Olivier consistently reworks his paintings, methodically photographs each stage, and then animates them into seamless, contemplative films that emphasize not only his sensuous brushstrokes but also transformation and impermanence. One fascinating aspect of Hawthorne's book is the portrait of Colonel Pyncheon; although his image is painted, his spirit seems to haunt the representation. Hawthorne writes, "All through the foregoing conversation between Mr. Pyncheon and the carpenter, the portrait had been frowning, clenching its fist, and giving many such proofs of excessive discomposure."[38] Though oil paint can take an extraordinarily long time to dry thoroughly and is susceptible to changes due to exposure to light and humidity, the variations that Hawthorne occasionally infers could only be supernatural or fantastical in origin, much like the aging portrait in Oscar Wilde's *The Picture of Dorian Gray* (1891).

Peter Krashes's painting *Camera Bank for the Governor* (2012) engages with portraiture of a more official nature, and particularly the ways people visually situate themselves to convey power. Whereas Colonel Pyncheon communicated his authority through religious and military iconography by posing for his portrait with a Bible in one hand and a raised sword in the other, the contemporary governor in Krashes's painting established his political status by staging a press event next to a historical portrait and a bank of flags in the Brooklyn Borough Hall's stately courtroom.[39] Consistent with Hawthorne's critiques of institutional power, Krashes's work—which stems directly from his activism—explores complex issues of governmental corruption, community empowerment, and property rights. He attended this press event to speak to the Governor of New York about a pertinent

real estate project that was infringing on the rights of citizens in his neighborhood. In the artist's words, "What legacy is implied by the room is not treated with much sincerity by the government officials who use it…. The event was staged to reach the eyes and ears beyond the room…. It was a stage performance for the news cycle."[40] Working from his own photograph, Krashes not only re-represents the historical portrait and the crushing bank of news cameras, but he addresses the photographic language of that equipment by painting the effects of a camera flash over much of the composition. Unlike Holgrave's daguerreotypes, whose images flit in and out of vision and reveal hidden characteristics, the inescapable daily news cycles perpetuated by these cameras rarely delve into complex issues.

Andreas Fischer's *Sunday Best* (2009), a small oil painting from a series of the same name, critically explores the relationship between photography and painting, memory and history. Based on found tintype portraits from the 1800s, the artist spent three years making the paintings and thinks of them in terms of "images as a contested platform for social negotiation."[41] Fischer was not simply repainting specific photographs but using them as a departure point for engaging with the history of photographic portraits and the social and economic circumstances surrounding their creation. As Ronald R. Thomas writes:

> Photography's presence in *The House of the Seven Gables* is not just as an observer but as an actor in a cyclical history, the course of which he is determined to alter. That he [the daguerreotypist] is there at all is the result of fundamental shifts in social organization that are taking place at the opening of the narrative.[42]

Like the daguerreotype, the tintype represented a democratic shift in representation. Ordinary people could possess images, as opposed to when the wealthy Colonel Pyncheon commissioned his painted portrait. Identifying the entire tradition of portraiture as "image casting," Fischer is also interested in the convention of people dressing in their church clothes to pose for their portraits; here, a stern man with a ghastly complexion, high forehead, and wavy hair is clad in his drab but sensible brown suit and tie.[43] For Fischer, as for Cézanne, the backgrounds are as important as the figure, so the works are not just portraits "but paintings with a contested spatial relationship" analogous to the social issues that interest him.[44]

Like the sitter in Fischer's painting, Dale, the subject of Katy Grannan's *Dale, Pacifica (1)* (2007) seems to be wearing her "Sunday best." Grannan's large-format camera allows for sharp details as well as blurring around the figure, and one imagines Dale to have posed in perfect stillness like the sitters for daguerreotypes or tintypes. The image evokes the isolation of Hepzibah Pyncheon; haunted by generations of familial trauma, she leads a reclusive life filled with anxiety about being seen. This photograph is one from a series about Gail and Dale, "middle-aged transsexuals and best friends whose experience in the world is mediated by romantic escapism and willful delusion."[45] (The artist often develops relationships with previously unknown subjects and works collaboratively with them to

make photographs.) Grannan describes their "solitary inner lives" and "deeper existential need to be visible."[46] Depicted alone on a beach, Dale is stretched before the camera in a sparkling flesh-colored dress that threatens to blend into the sand, with wispy white hair that seems an extension of the flat gray sky and rolling sea. The passage of life is written in the lines on her face and in her penetrating eyes but it is reinforced by the Hallmark tropes of crashing waves and footprints in the sand. She exudes an otherworldly presence, much like Hepzibah, who says, "We are ghosts ourselves."

Just as Grannan's work might evoke Hepzibah, the pathos inherent in the reclining wormlike form in Jan Bünnig's *Nice Shape* (2006) can provide a point of access for Hepzibah's brother, Clifford's, regression to a childlike state as a result of his wrongful imprisonment for the presumed murder of a family member. Loosely wrapped in a floral blanket on a meager mattress on the floor, the variegated phallic shape, made of polyurethane foam enclosed in sausage casing, appears weak, vulnerable, and alone. In keeping with many of Bünnig's other works—often comprised of household objects, natural elements, and some degree of human interaction—*Nice Shape* includes a performative element. When the artist has exhibited the work in the past, he has slept in the freshly made bed the night before the opening reception "and left a sculpture in the morning like a real rest of my dreams."[47] This sentiment echoes Bünnig's "fundamental desire to extend the beauty of a moment."[48] In writing about the aesthetic dimension of the uncanny, Vidler identifies it as a "representation of a mental state of projection that precisely elides the boundaries of the real and the unreal in order to provoke a disturbing ambiguity, a slippage between waking and dreaming."[49] That slippage, in this context, can be linked to Clifford's unjust thirty-year imprisonment, a hibernation period of sorts. Hawthorne does not reveal any details about Clifford's years in prison; he only discusses his life before his incarceration and after his release, leaving a gaping hole in the history of the character's life.

Hawthorne deploys the uncanny notion of doubling in his development of characters other than Hepzibah and Clifford. The mirroring of vases and bouquets in Bill Conger's *Our Lady of the Flowers* (2012) evokes the author's use of doubling throughout generations: Judge Pyncheon and Colonel Pyncheon, Holgrave and Matthew Maule, and most relevantly in this case, Phoebe Pyncheon and Alice Pyncheon. Hawthorne describes both women in terms of ephemeralities like flowers, music, and light, emphasized here by Conger's twin arrangements and their stark attendant shadows. The artist's sculptural mirror image of white ceramic vases perpetually filled with fresh flowers asserts an eerie presence in the room. The narrow stems should not support the full weight of their counterparts as well as a second heavy vase, yet they do, prompting a sense of wonder and causing a viewer to question his perceptions. The fresh flowers are replaced periodically throughout the exhibition, changing not only their position on the spectrum of decay but also their color and type. For returning visitors, it is a subtle and mysterious transformation that

forces them to search their own recollections of a space they may have frequented only the day before. Importantly, these colorful bouquets emit a mild smell. Lightly punctuating the air, they bring a sense of the olfactory-induced joy that Clifford experienced when Phoebe presented him with a small crimson rose.[50] In keeping with Hawthorne's sense of time, Conger's impermanent materials embody the fleeting nature of memories and life itself. As with many of the artist's titles, *Our Lady of the Flowers* offers multiple readings, from the religious history of the Catholic Church's naming of saints to the debut novel of French writer Jean Genet.

Anne Collier's *Aura (Cerith Wyn Evans)* (2003), an aura portrait of the Welsh artist Cerith Wyn Evans—an artist whose photographs, sculptures, installations, and films find their inspiration in the interstices of language, beautifully uniting the conceptual and romantic realms—recalls the introspective character of Holgrave, the daguerreotypist harbinger of truth and modernity, the mesmerist with an enchanted ancestry, the democratic and contemplative artist/writer. An ominous red glow appears to emanate from Evans's breast to encircle his head and shoulders like an airbrushed veil. *Aura (Cerith Wyn Evans)* is one from a series of aura portraits of fellow artists that Collier staged at a psychic store in Oakland. The subjects would sit in front of the camera and rest their hands on metal sensors connected to a camera and a computer to show the sitter's aura, their "human spiritual energy," which is purportedly unseen to the eye and requires special equipment to capture.[51] Likewise, Hawthorne utilizes Holgrave and his daguerreotypes as a means of exposing secrets that the embodied eye would not otherwise see. The mystical "Maule-eye," an "evil eye" that could cast a hypnotic spell on its objects, receives a modern makeover as Holgrave's all-seeing photographic eye.[52] Collier's use of aura photography directly references supposed supernatural powers and photographic "seeing," evoking the opposing tensions between technology/magic and religion/witchcraft that recur throughout *The House of the Seven Gables*. Known for her precise photographs of record albums, magazine advertisements, and book covers in clinically pristine settings, in this work, Collier releases control to a Polaroid camera. The artist has said that her *Aura* works "make a sideways reference to the nineteenth-century attempts to record—through photography—the paranormal."[53]

As in Collier's portrait, Dario Robleto's *Diary of a Resurrectionist (I'll be Waiting for You) b/w A Mourner Learns to Relinquish the Lost* (2003-2004) refers to nineteenth-century ideas linking photographic technology to magic.[54] The artist fastidiously constructed photo albums from a bewitching amalgam of materials—including cast and carved bone dust, fragments of soldiers' personal mirrors, and melted vinyl from Jackie Wilson's "Lonely Teardrops" album and Irma Thomas's "Time is on My Side/Anyone Who Knows What Love is Will Understand" album—in order to encase antique "spirit" photographs. (Consistent with Spiritualism's belief that the dead could communicate with the living,

spirit photographs—which rose to popularity in the 1860s and included imagery of shadowy or semi-transparent figures that were not visible during the portrait session—were thought to show the evidence of ghosts, particularly deceased family members.)[55] Although the albums contain multiple spirit photographs, the one most commonly on view is from Robleto's personal collection (as in Botz's *Untitled*) and poignantly comments on the precious nature of family photographs. The haunting image of two naval cadets was taken by their mother before they shipped out for the war that would kill them both.[56] In an eerie foreshadowing of their fate, the uniformed men look like seemingly faceless apparitions. Just as Hepzibah ritualistically visited her miniature portrait of Clifford in his absence, one can imagine that the soldiers' mother may have held this image close. Robleto's poetic configurations of actual artifacts and carefully constructed relics thoughtfully comment upon time, history, faith, and collective experiences in a sincere attempt to address, as curator Elizabeth Dunbar put it, "humanity's need for love and redemption."[57]

Like Hawthorne, the artist investigates links separated by gulfs of time. A storyteller, poet, and DJ by nature, Robleto favors a primacy of language; he writes titles and material lists that read like incantations, poems, or liner notes before creating his sculptural objects. His choice of "Resurrectionist" for the title of this work—a word that simultaneously refers to a person who brings something to life, a believer in resurrection, and a grave robber who primarily steals dead bodies for dissection—and his inclusion of bone dust from every bone in the human body resonates with spiritual, familial, and historical overtones. Robleto draws attention to the losses suffered by military families throughout American history, memorializes an individual mother's mourning and extrapolates it to a collective community of grief, and, finally, metaphorically reanimates those for whom the "Lonely Teardrops" were cried.

The materials constituting Reed Barrow's *there and back again* (2008) are particular to his own comment on loss, longing, and an empty resurrection. The artist cast his childhood chair before grinding it to bits and remaking it from the sawdust and glue. While technically he has just made particle board, an inexpensive building material, the essence of the piece is in the melancholic repetition of its construction. Barrow offers a compelling meditation on the symbols that populate one's memories, both those that we desperately cling to and those that we attempt to tear down. Though he consciously destroys and tries to recapture an emblem of his youth, his focus on the transitions between childhood and adulthood emphasize the generational shifts faced by all families, Pyncheon or otherwise. Small in stature, between a toy and full-size furniture, the hard chair conveys neither comfort nor warmth; it sits alone waiting for someone to populate its seat. Chairs function as a space to support bodies at rest, and Colonel Pyncheon and Judge Pyncheon both meet their pivotal apoplectic deaths in chairs within the House of the Seven Gables.

The sense of loss is palpable in Alice Hargrave's *home (movies): blue ridge* (2004). The title alone immediately implies a familial sense of place and the recording of one's kin.

As in her *untitled (family pictures & portraits)* series, Hargrave examines the links between the transient nature of photography and that of memory itself.[58] Her image has gone through multiple levels of mediation—she extracted a single frame from an 8mm film, transferred it to video, and captured it digitally—resulting in image disintegration and decay. Throughout the transfer process, Hargrave revisited both the image and its attached memory, each time recapturing yet simultaneously losing a little bit more. This moment is still, a frame frozen and isolated from countless others that together transmit a sense of motion. The twisting, grasping branches of the tree in the foreground call to mind the Pyncheon Elm, which has served as a navigational beacon for the House of the Seven Gables for generations. As the town has grown up around the Pyncheon home, the tree has weathered the changes, continuing to shield the dark house from all but the most vigilant of the sun's rays.

The Pyncheon Elm is not the only plant Hawthorne refers to throughout *The House of the Seven Gables*; he utilizes flora, such as Alice's posies or the white roses in the garden to both reinforce temporality and describe the house's level of dreariness in particular moments. Anya Gallaccio's *like we've never met* (2003) poetically engages with the inevitability of decay. Unlike Conger's flowers, this work's original 148 brightly colored Gerber daisies have been allowed to wilt and mold since their initial pressing between the panes of glass in a set of large mahogany glazed doors. The decomposition has yielded a variety of drips and stains, also preserved in the glass. This eventual dematerialization is fundamental to most of Gallaccio's work, whether she employs daisies, as she has in multiple works, apples, potatoes, salt, wax, or tree trunks. At the time of this writing, the daisies have deteriorated to such a point that, although the stems still have some body in them, many of the petals appear to be painted or etched onto the window, a fitting analogy for the image on one of Holgrave's daguerreotype plates.

One can imagine that Gallaccio's doors once belonged to a great house like the one Hawthorne describes; however, like the titular home in the book, these doors have fallen into a state of disrepair. Though the wood is still solid, the doors—removed from their original purpose and leaning against a wall without hardware, keys, or knobs, and pockmarked by the holes where fixtures once resided—no longer function as a means of entry, but rather as a ghost of a forgotten place. Importantly, the flowers conceal a view beyond the great doors, allowing for some degree of secrecy. When Hepzibah, Hawthorne's reclusive protagonist, opens a small shop inside the house—an occupation that causes her to experience great class-based shame and social anxiety—Hawthorne specifically draws the reader's attention to the store's door as the transition point between the weary Pyncheon and the public.

Benjamin Gardner was inspired to make *thy hope forgiving* (2013) by reading about Hepzibah's shop in the house. The artist imagined the goods on the store shelves as he made the "memory jars" that populate his "aged" wooden supports. The mason jars contain bits of writing and detritus from the artist's studio but the contents are mostly

hidden from the viewer by thick layers of plaster. The front of each jar displays a letter—S, A, T, O, R—sometimes hand-written in pencil on paper, sometimes formed from negative space within milky white paint. The 5 x 5 configuration of lettered containers forms a sator square, "a palindrome square reading the same in every direction" that comes from "a history of magic and mysticism."[59] The configuration of letters allows the emergence of other Latin words: opera, tenet, arepo, and rotas. Dating as far back as the ruins of Pompeii, the sator square is a mysterious, talismanic object whose secret meaning has prompted much speculation but ultimately remains unknown. Drawn into the background of the shelving unit is a circle, partially concealed by the jars, with handwritten text reading: "For health of heart and home, for lands of plenty not our own," a fitting incantation for the property-hungry Pyncheon clan. Like Hawthorne, one of the primary strengths of Gardner's work is his ability to weave occasionally divergent threads of histories—in this case, folk art, modern art, mysticism, and ancient civilizations—into a singular vision of the ineffable.

Brian Kapernekas's *Witch Stick* (2005-2012), and Gardner's *thy hope forgiving*, offer (mostly) concealed archives of the interiors of the artists' own homes. Gardner allows twigs, scraps, fabric, and letters to peek out from his plaster tombs, while Kapernekas only hints at what has been swept into the inaccessible depths of his broom through a textual inventory on his material list (coffee can, drawings, electrical tape, stones). Like family histories shrouded in legend, hearsay, and rumor, *Witch Stick* alludes to its constitution but the information remains just out of reach. Like Bob Jones, Kapernekas employs one of the most recognized Halloween motifs, in this case, the broomstick. Unlike its fantastical cartoon counterparts, this one does not fly. Instead, it magically stands upright with no support, connecting it more to a broom's utilitarian purpose and the gendered domestic sphere in which it has traditionally resided, perhaps in subtle acknowledgement of the primarily female persecution in the Salem Witch Trials. When magistrate John Hathorne examined Mary Lacey, Jr. in one of the Trials, he actually asked her, "Did you at any time use[d] to ride upon a stick? Do you not anoint yourself before you fly?"[60]

John Hathorne's irrational beliefs, fueled by superstition, exemplify the history that Hawthorne was critiquing. The fear of the unknown that was at the heart of the Salem Witch Trials, and, consequently, Hawthorne's personal haunting, permeated his writing. The author's richly layered language allowed ample room for interpretation, and what began for me as a visual approach to interpreting a specific work of literature grew to an exploration of themes that unite artists, writers, readers, and viewers across centuries. As mentioned in the introduction of this essay, Hawthorne described *The House of the Seven Gables* as an "attempt to connect a by-gone time with the very Present that is flitting away from us." Trachtenberg embraced Hawthorne's use of photographic metaphors when he expanded upon that sentiment with "The present flits away just as does the picture on the mirror-like surface of the daguerreotype."[61] What is it about the inexorable passage of time

that continually piques our interest? Is it a universal feeling with which each of us has to contend? That which science has not enabled us to do—to stop or slow time—persistently perplexes, intrigues, and haunts. The artworks included here evidence a reckoning with one's historical condition, whether individual or collective. Just as Hawthorne was writing at a time when the nation was on the precipice of sweeping transformation and change, both through industrialization and the impending Civil War, most of the artists in the exhibition are working at a time of unprecedented technological change, interconnectedness in a globalized economy, and constant threats from terrorism and climate change. The works in the exhibition address themes of photography, haunting, and the architectural uncanny culled from Hawthorne's text, but, importantly, they evidence the anxiety of the contemporary age. These artists make marks and salvage histories among the increasingly digital dustbins of an online world. They savor temporality and luxuriate in exploring signifiers of time and memory.

This brings us back to Hawthorne's notion of a house: what should be the ultimate personal shelter and retreat is instead haunted by the memories of generations of misdeeds. Hawthorne, of course, is not the only writer to connect the past to the present through this trope; writers ranging from Edgar Allan Poe to H. P. Lovecraft to Stephen King, in various ways, have explored just that. What do we still respond to in the idea of a haunted house? In both literature and the collective consciousness, it allows a space for projection of (sometimes otherwise unspeakable) fears, desires, and even social commentary. And an unexplainable hint of a movement, scent, or sound may offer correspondence with either an unattainable past or the unknown. Like Holgrave with his daguerreotypes, many of us are looking for those mysterious moments that cause us to pause and question what might be hidden beneath the surface of the everyday. At the end of *The House of the Seven Gables*, the main characters in the current generation retire to a country house; free from the tyranny of the now-deceased Judge Pyncheon and the house itself, they all live happily ever after. Although this sudden "happy ending" feels unexpected, Hawthorne leaves the reader with a glimmer of the fantastic in his last lines. As the family departed, Maule's Well was "throwing up a succession of kaleidoscopic pictures;" the Pyncheon Elm "whispered unintelligible prophecies;" and strains of music from the deceased Alice Pyncheon's harpsichord were heard as "she floated heavenward from the House of the Seven Gables!"[62] Perhaps if we too listen closely for the whispered voices from the past, we will not only release ourselves from repeating shadowy transgressions but also discover fleeting shimmerings of the otherworldly in our daily lives.

—Kendra Paitz is Curator of Exhibitions at University Galleries of Illinois State University.

The title of this essay quotes Nathaniel Hawthorne. See Nathaniel Hawthorne, *The House of the Seven Gables* (New York: Simon & Schuster Paperbacks, 2010), 210.

1. Presaging the portraits he would include in *The House of the Seven Gables*, Hawthorne wrote in his notebook about the painting of his own portrait: "I have had three portraits taken before this,—an oil picture, a miniature, and a crayon sketch,—neither of them satisfactory to those most familiar with my physiognomy. In fact, there is no such thing as a true portrait; they are all delusions, and I never saw any two alike, nor hardly any two that I would recognize, merely by the portraits themselves, as being of the same man." See Nathaniel Hawthorne, *Passages From The American Notebooks, Volume 2*. Accessed June 20, 2012, http://www.gutenberg.org/files/8089/8089-h/8089-h.htm.

2. Alan Trachtenberg, "Seeing and Believing: Hawthorne's Reflections on the Daguerreotype in *The House of the Seven Gables*," *American Literary History*, Volume 9, No. 3 (Autumn, 1997): 462.

3. For a synopsis of major characters, please see page 106.

4. Hawthorne, 11.

5. Ibid.

6. Hawthorne drew on his own regional and familial history to create the settings, scenarios, and characters to such a degree that he received a letter from a Thomas R. Pynchon asking him to change the name of the family in the book fearing that it would reflect poorly on his own. See Thomas R. Pynchon, letter to Nathaniel Hawthorne, June 10, 1851, Nathaniel Hawthorne Collection of Papers, Incoming Correspondence, Berg Collection, New York Public Library (New York, New York). Additionally, although *The House of the Seven Gables* was classified as a "romance" at the time of its publication, I am using the word "novel" throughout this essay for the ease of the contemporary reader. For more information on the distinctions between a romance and a novel, see Milton R. Stern's introduction to 1986 Penguin Classics edition of *The House of the Seven Gables*.

7. Enders A. Robinson, *Salem Witchcraft and Hawthorne's* The House of the Seven Gables (Berwyn Heights, MD: Heritage Books, Inc., 2010), 205.

8. Robinson, 2.

9. Richard Davenport-Hines, *Gothic: Four Hundred Years of Excess, Horror, Evil and Ruin* (New York: North Point Press, 2000), 267.

10. Anthony Vidler, *The Architectural Uncanny: Essays in the Modern Unhomely* (Cambridge: The MIT Press, a division of Farrar, Straus and Giroux, 1994), 17.

11. Gaston Bachelard, *The Poetics of Space* (Boston: Beacon Press, 1994), 17.

12. Sigmund Freud, "The Uncanny" in *The Uncanny* (London: Penguin Books, 2003), 124.

13. Freud, 148.

14. Trachtenberg, 468.

15. Trachtenberg, 472.

16. Hawthorne, 4.

17. Roland Barthes, *Camera Lucida: Reflections on Photography* (New York: Hill and Wang, a division of Farrar, Straus and Giroux, 1981), 77.

18. Robinson, 91.

19. No stranger to memorializing female histories, Botz gained acclaim for her *Nutshell Studies of Unexplained Death*, for which she photographed the intensely detailed miniature crime scene dioramas made in the 1940s and 1950s by criminologist Frances Glessner Lee.

20. Marilyn R. Chandler, *Dwelling in the Text: Houses in American Fiction* (Berkeley: University of California Press, 1991), 69.

21. The artist incorporated Edwards's sermon and excerpts from "Written 20 Years After the Novel," Joris-Karl Huysmans's preface for the 20-year anniversary re-printing of *Against Nature* in the monologues. See http://www.suedebeer.com/thequickening.html.

22. Hawthorne, 32. This may have been Hawthorne's nod to Edgar Allan Poe's 1843 short story *The Tell-Tale Heart*.

23. Mary Barone, "Angels and Alligators," accessed July 5, 2013, http://www.artnet.com/magazineus/features/barone/barone6-17-08.asp.

24. Chandler, 69.

25. I wrote a version of this phrase about Conger's work for my 2012 essay "The inescapable future past," available at http://www.nowwerealonenow.com/.

26. Anthony Vidler, *Warped Space: Art, Architecture, and Anxiety in Modern Culture* (Cambridge: The MIT Press, reprint edition, 2002), 153.

27. Overby's latex casts of interior walls, corners, and doors can be seen as a direct precursor for later works by artists such as Heidi Bucher and Rachel Whiteread.

28. Terry R. Myers, "Going Overby," in *Robert Overby: Parallel: 1978-1969* (Los Angeles: Hammer Museum at University of Los Angeles, 2000), 84.

29. Myers, 64.

30. *Two Window Wall Map* precisely maps a wall that Overby had already cast in latex rubber, most likely his 1971 *East room with 2 windows, third floor* from the *Barclay House* series.

31. Hawthorne, 7.
32. Benjamin Gardner, email message to author, October 30, 2012.
33. Ibid.
34. See Kendra Paitz, "Toward an Ethical Representation of Sarah Winchester" (MA thesis, Illinois State University, 2011). See http://www.winchestermysteryhouse.com for additional information about Sarah Winchester's home.
35. Paul Schimmel, "Life's Echo: Gregor Schneider's Dead House u r" in *Gregor Schneider* (Milano/New York: Charta, 2004), 103.
36. Schimmel, 107. For a list of Schneider's title variations for components of the project, see the index in *Gregor Schneider* (Milano/New York: Charta, 2004).
37. Schimmel, 107.
38. Hawthorne, 226.
39. And not only Colonel Pyncheon, but also Judge Pyncheon—a family member expecting to be nominated for Governor who concealed his deceitful inner character from the surrounding community. The judge functions as the colonel's doppelgänger, defined by Freud as someone who has "to be regarded as identical because they look alike… [with] the constant recurrence of the same thing, the repetition of the same facial features, the same characters, the same destinies, the same misdeeds, even the same names, through successive generations." See Freud 141-142.
40. Peter Krashes, email message to author, August 13, 2012.
41. Andreas Fischer, conversation in the artist's studio, November 20, 2012.
42. Thomas, 157.
43. Fischer, conversation, November 20, 2012.
44. Ibid.
45. Salon 94, "Lady into Fox," 2008. Accessed July 10, 2011, http://www.salon94.com/exhibitions/detail/lady-into-fox.
46. Ibid.
47. Jan Bünnig, email message to the author, April 18, 2012.
48. Susanne White, Heidelberger Kunstverein. "Jan Bünnig: We Stay Up to 1000 Clock," February 2013. Accessed February 2014, http://www.mukimaki.de/ka20.php.
49. Vidler, *The Architectural Uncanny*, 11.
50. Hawthorne, 127.
51. Anne Collier, "Strange Powers," 2006. Accessed October 10, 2011, http://creativetime.org/programs/archive/2006/strangepowers/site/collier.html.
52. Trachtenberg, 466.
53. Collier, "Strange Powers."
54. "The Diary of a Resurrectionist" is also a portion of the title of James Blake Bailey's book related to body snatching: T*he Diary of a Resurrectionist, 1811-12, To Which Are Added an Account of the Resurrection Men in London and a Short History of the Passing of the Anatomy Act.*
55. For more information on spirit photography, see Louis Kaplan's 2008 book, *The Strange Case of William Mumler, Spirit Photographer.*
56. Dario Robleto, telephone conversation with author, June 7, 2012.
57. Elizabeth Dunbar, "The Reconstructionist" in *Alloy of Love* (Saratoga Springs, New York: Frances Young Tang Teaching Museum and Art Gallery, Skidmore College, 2008), 211.
58. Alice Hargrave, conversation with author in the artist's studio, November 20, 2012.
59. Benjamin Gardner, email message to author, April 12, 2012.
60. Robinson, 2.
61. Trachtenberg, 461.
62. Hawthorne, 365.

Kendra Paitz, curator of the exhibition, selected relevant passages from *The House of the Seven Gables* to pair with the artworks. All citations are from the 2010 Simon & Schuster paperback edition.

III.

ARTWORKS.

I. Reed Barrow. 45
II. Corinne May Botz. 33, 35, 51
III. Jan Bünnig. 67
IV. Anne Collier. 61
V. Bill Conger. 69, 83
VI. Drew Conrad. 37
VII. Sue De Beer. 85
VIII. Rachel Feinstein. 81
IX. Andreas Fischer. 63
X. Anya Gallaccio. 73
XI. Benjamin Gardner. 41, 75
XII. Katy Grannan. 65
XIII. Alice Hargrave. 71
XIV. Bob Jones. 79
XV. Brian Kapernekas. 77
XVI. Rachel Khedoori. 49
XVII. Peter Krashes. 57
XVIII. Jacco Olivier. 53, 59
XIX. Robert Overby. 39
XX. Dario Robleto. 55
XXI. Gregor Schneider. 47
XXII. Sarah E. Wood. 43

I believe I am a little mad. This subject has taken hold of my mind with the strangest tenacity of clutch since I have lodged in yonder old gable. As one method of throwing it off, I have put an incident of the Pyncheon family history, with which I happen to be acquainted into the form of a legend, and mean to publish it in a magazine.

—Hawthorne, 213.

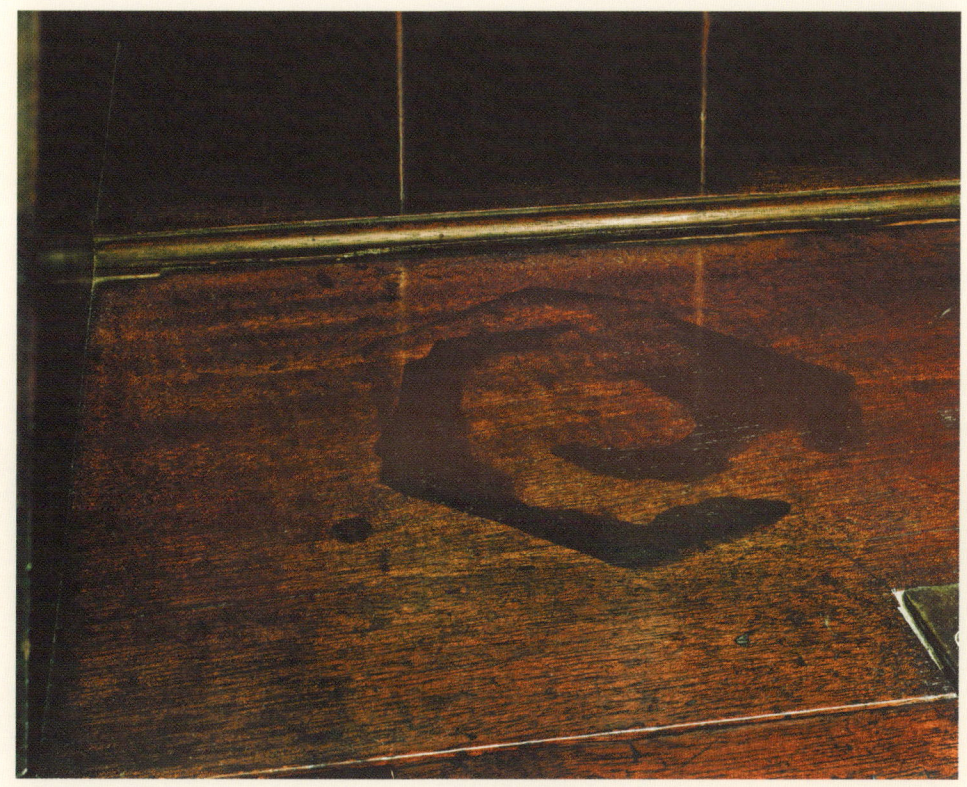

Corinne May Botz
Nathaniel Hawthorne's Desk (Ink Stain)
2012
Archival pigment print
20 x 24 x 2 inches
Courtesy of the artist and Bonni Benrubi Gallery, New York

The house might just as well be buried in an eternal fog while all other houses had the sunshine on them; for not a foot would ever cross the threshold, or a hand so much as try the door!

—Hawthorne, 58.

CORINNE MAY BOTZ
Rebecca Nurse Homestead
2012
Archival pigment print
24 x 20 x 2 inches
Courtesy of the artist and Bonni Benrubi Gallery, New York

> Now, this old Pyncheon House! Is it a wholesome place to live in, with its black shingles, and the green moss that shows how damp they are; its dark, low-studded rooms; its grime and sordidness, which are the crystallization on its walls of the human breath that has been drawn and exhaled here in discontent and anguish? The house ought to be purified with fire—purified till only its ashes remain!
>
> —Hawthorne, 210-211.

Drew Conrad
Remnant No. 3 (Chelsea Hotel)
2012
Mixed media
11 x 33 x 7 inches
Courtesy of the artist and Fitzroy Gallery, New York

It seemed as if the house stood in a desert, or, by some spell, was made invisible to those who dwelt around, or passed beside it; so that any mode of misfortune, miserable accident, or crime might happen in it without the possibility of aid.

—Hawthorne, 278.

ARTWORKS.

ROBERT OVERBY

Two Window Wall Map
20 August 1972
Canvas
105.5 x 160 inches
Courtesy of the Estate of Robert Overby and Marc Selwyn Fine Art, Los Angeles

His home would include the home of the dead and buried wizard, and would thus afford the ghost of the latter a kind of privilege to haunt its new apartments, and the chambers into which future bridegrooms were to lead their brides, and where children of the Pyncheon blood were to be born. The terror and ugliness of Maule's crime, and the wretchedness of its punishment, would darken the freshly plastered walls, and infect them early with the scent of an old and melancholy house.

—Hawthorne, 12.

ARTWORKS.

BENJAMIN GARDNER

mesmerism and 16 lights #9 (or, the transformation)
2012
Acrylic, graphite, ink on panel
24 x 18 x 2 inches
Courtesy of the artist

The shadow creeps and creeps, and is always looking over the shoulder of the sunshine.

—Hawthorne, 219.

ARTWORKS.

SARAH E. WOOD
Window Shadow
2008
Plastic mesh
72 x 96 x 30 inches
Courtesy of the artist and Kate Werble Gallery, New York

Still, there will be a connection with the long past—a reference to forgotten events and personages, and to manners, feelings, and opinions, almost or wholly obsolete—which, if adequately translated to the reader, would serve to illustrate how much of old material goes to make up the freshest novelty of human life.

—Hawthorne, 8.

REED BARROW

there and back again
2008
Sawdust, glue
Courtesy of the artist

Never had the old house appeared so dismal to poor Hepzibah as when she departed on that wretched errand. There was a strange aspect in it. As she trod along the footworn passages, and opened one crazy door after another, and ascended the creaking staircase, she gazed wistfully and fearfully around. It would have been no marvel to her excited mind, if, behind or beside her, there had been the rustle of dead people's garments, or pale visages awaiting her on the landing place above.

—Hawthorne, 273.

Gregor Schneider
HAUS U R, Rheydt, 1985-today
1996
DVD, running time 26:12 minutes
Courtesy of the artist and Galerie Luis Campaña, Berlin

> As regards its interior life, a large, dim looking glass used to hang in one of the rooms, and was labeled to contain within its depth all the shapes that had ever been reflected there—the old Colonel himself, and his many descendants, some in the garb of antique babyhood, and others in the bloom of feminine beauty or manly prime, or saddened with the wrinkles of frosty age. Had we the secret of that mirror, we would gladly sit down before it, and transfer its revelations to our page.
> —Hawthorne, 24-25.

ARTWORKS.

RACHEL KHEDOORI
Ohne Titel (Pink Room)
2000
Eiki 16 mm projector, metal shelf, projection screen, mirror, 16 mm film copy (4:00 minutes, looped)
Exhibition copy
Courtesy of the artist and Hauser & Wirth, London

This picture, it must be understood, was supposed to be so intimately connected with the fate of the house, and so magically built into its walls, that, if once it should be removed, that very instant the whole edifice would come thundering down in a head of dusty ruin.

—Hawthorne, 227.

ARTWORKS.

CORINNE MAY BOTZ

Untitled
2011
Archival pigment print
30 x 40 x 3 inches
Courtesy of the artist and Bonni Benrubi Gallery, New York

My impression is that our wonderfully increased and still increasing facilities of locomotion are destined to bring us round again to the nomadic state. You are aware, my dear sir—you must have observed it in your own experience—that all human progress is in a circle: or to use a more accurate and beautiful figure, in an ascending spiral curve. While we fancy ourselves going straight forward, and attaining, at every step, an entirely new position of affairs, we do actually return to something long ago tried and abandoned, but which we now find etherealized, refined, and perfected to its ideal.

—Hawthorne, 296.

JACCO OLIVIER
Return
2007
Animation on DVD, 1:14 minutes
Projected at 45 x 75 cm
Courtesy of the artist and Marianne Boesky Gallery, New York

There is sad confusion, indeed, when the spirit thus flits away into the past, or into the more awful future, or, in any manner, steps across the spaceless boundary betwixt its own region and the actual world.

—Hawthorne, 78.

Dario Robleto

Diary of a Resurrectionist (I'll Be Waiting For You) b/w A Mourner Learns to Relinquish the Lost
2003-2004
Photo albums: Cast and carved bone dust, dehydrated bone calcium, crushed amino acids, melted vinyl records of Jackie Wilson's "Lonely Teardrops" and Irma Thomas' "Time Is On My Side/Anyone Who Knows What Love Is (Will Understand)," homemade paper made from cotton and bone dust from every bone in the body, fragments of soldiers' personal mirrors, spirit of ammonia, myrrh resin, copper, mica, water extendable resin, rust, pigments, velvet, bone glue, typeset. Photographs and tintypes: Antique "spirit photographs" (detection of a ghost or spirit disturbance on photographic film)
7 x 5.5 inches each
Collection of Robin Wright and Ian Reeves

What is there so ponderous in evil that a thumb's bigness of it should outweigh the mass of things not evil which were heaped into the other scale! This scale-and-balance system is a favorite one with people of Judge Pyncheon's brotherhood. A hard, cold man, thus unfortunately situated, seldom or never looking inward, and resolutely taking his idea of himself from what purports to be his image as reflected in the mirror of public opinion, can scarcely arrive at true self-knowledge, except through loss of property and reputation. Sickness will not always help him do it; not always the death hour!

—Hawthorne, 264.

PETER KRASHES

Camera Bank for the Governor
2012
Gouache on paper
48 x 72 inches
Courtesy of the artist

And finally, at Matthew Maule's audacious suggestion of a transfer of the seven-gabled structure, the ghostly portrait is averred to have lost all patience, and to have shown itself on the point of descending bodily from its frame. But such incredible incidents are merely to be mentioned aside.

—Hawthorne, 226.

JACCO OLIVIER

Portrait
2009
Animation on DVD, 1:35 minutes
Projected at 40 x 30 cm
Courtesy of the artist and Marianne Boesky Gallery, New York

There is wonderful insight in heaven's broad and simple sunshine. While we give it credit only for depicting the merest surface, it actually brings out the secret character with a truth that no painter could ever venture upon, even could he detect it.

—Hawthorne, 106.

ARTWORKS. 61

ANNE COLLIER
Aura (Cerith Wyn Evans)
2003
Color polaroid
4.25 x 3.375 inches
Courtesy of the artist and Anton Kern Gallery, New York

At length, she paused before the portrait of the stern old Puritan, her ancestor, and the founder of the house. In one sense, this picture had almost faded into the canvas, and hidden itself behind the duskiness of age; in another, she could not but fancy that it had been growing more prominent, and strikingly expressive, ever since her earliest familiarity with it as a child. For, while the physical outline and substance were darkening away from the beholder's eye, the bold, hard, and, at the same time, indirect character of the man seemed to be brought out in a kind of spiritual relief. Such an effect may occasionally be observed in pictures of antique date. They acquire a look which an artist (if he have anything like the complacency of artists nowadays) would never dream of presenting to a patron as his own characteristic expression, but which, nevertheless, we at once recognize as reflecting the unlovely truth of the human soul. In such cases, the painter's deep conception of his subject's inward traits has wrought itself into the essence of the picture, and is seen after the superficial coloring has been rubbed off by time.

—Hawthorne, 69.

ARTWORKS.

ANDREAS FISCHER

Sunday Best
2009
Oil on canvas
11 x 9 inches
Courtesy of the artist and Andrew Rafacz Gallery, Chicago

Evidently, this is to be a day of more than ordinary trial to Miss Hepzibah, who, for above a quarter of a century gone by, has dwelt in strict seclusion, taking no part in the business of life, and just as little in its intercourse and pleasures. Not with such fervor prays the torpid recluse, looking forward to the cold, sunless, stagnant calm of a day that is to be like innumerable yesterdays!

—Hawthorne, 37.

KATY GRANNAN

Dale, Pacifica (1)
2007
Archival pigment print
40 x 50 x 2.5 inches
Courtesy of the artist and Salon 94, New York

Had Clifford, every time that he emerged out of dreams so lifelike, undergone the torture of transformation from a boy into an old and broken man, the daily recurrence of the shock would have been too much to bear. It would have caused an acute agony to thrill from the morning 'twilight, all the day through, until bedtime, and even then would have mingled a dull, inscrutable pain, and pallid hue of misfortune, with the visionary bloom and adolescence of his slumber. But the nightly moonshine interwove itself with the morning mist and enveloped him in a robe, which he hugged about his person, and seldom let realities pierce through; he was not often quite awake, but slept open-eyed, and perhaps fancied himself most dreaming then.

—Hawthorne, 195.

ARTWORKS.

JAN BÜNNIG
Nice Shape
2006
Mixed media with performance
Dimensions variable
Courtesy of the artist

The sick in mind, and perhaps, in body, are rendered more darkly and hopelessly so by the manifold reflection of their disease, mirrored back from all quarters in the deportment of those about them; they are compelled to inhale the poison of their own breath, in infinite repetition. But Phoebe afforded her poor patient a supply of purer air. She impregnated it, too, not with a wild-flower scent—for wildness was no trait of hers—but with the perfume of garden roses, pinks, and other blossoms of much sweetness, which nature and man have consented together in making grow from summer to summer, and from century to century. Such a flower was Phoebe, in her relation with Clifford, and such the delight that he inhaled from her.

—Hawthorne, 163-164.

ARTWORKS. 69

BILL CONGER

Our Lady of the Flowers
2012
Vases, fresh flowers
46 x 5 x 5 inches
Courtesy of the artist

The street is Pyncheon Street; the house is the old Pyncheon House; and an elm tree, of wide circumference, rooted before the door, is familiar to every town-born child by the name of the Pyncheon Elm. On my occasional visits to the town aforesaid, I seldom failed to turn down Pyncheon Street, for the sake of passing through the shadow of these two antiquities—the great elm tree and the weather-beaten edifice.

—Hawthorne, 7.

ALICE HARGRAVE

home (movies): blue ridge
2004
Archival pigment print
30 x 40 inches
Courtesy of the artist

However the flowers might have come there, it was both sad and sweet to observe how Nature adopted to herself this desolate, decaying, gusty, rusty old house of the Pyncheon family; and how the ever-returning summer did her best to gladden it with tender beauty, and grew melancholy in the effort.

—Hawthorne, 33.

ANYA GALLACCIO
like we've never met
2003
Found mahogany glazed doors, 148 Gerber daisies
91.14 x 26.97 inches each (two pieces)
Courtesy of the artist and Lehmann Maupin Gallery, New York

It might have been taken for a ghostly or phantasmagoric reflection of the old shopkeeper Pyncheon's shabbily provided shelves, save that some of the articles were of a description and outward form which could hardly have been known in his day.

—Hawthorne, 42.

BENJAMIN GARDNER
thy hope forgiving
2013
Glass jars, paint, plaster, debris, wooden shelves
35.5 x 30 x 5.5 inches
Courtesy of the artist

It is not the less certain, however, that awe and terror brooded over the memories of those who died for this horrible crime of witchcraft. Their graves, in the crevices of the rocks, were supposed to be incapable of retaining the occupants who had been so hastily thrust into them. Old Matthew Maule, especially, was known to have as little hesitation or difficulty in rising out of his grave as an ordinary man in getting out of bed, and was as often seen at midnight as living people at noonday.

—Hawthorne, 216.

ARTWORKS. 77

BRIAN KAPERNEKAS
Witch Stick
2005-2012
Studio debris, dust, paintings, paint tubes, sticks, coffee can, stones, bamboo sticks, twigs, painting rags, electrical tape, enamel, drawings, staples, packaging tape, wood
66 x 9 x 6 inches
Courtesy of the artist and 65GRAND, Chicago

...but Old Matthew Maule, it is to be feared, trode downward from his own age to a far later one, planting a heavy footstep, all the way, on the conscience of a Pyncheon. If so, we are left to dispose of the awful query, whether each inheritor of the property—conscious of wrong, and failing to rectify it—did not commit anew the great guilt of his ancestor, and incur all its original responsibilities.

—Hawthorne, 24.

BOB JONES

Father's Headdress
2006
Hydraulic cement, spray paint
14 x 11 x 9 inches
Collection of Steve Williams and Heidi O'Neill

Nothing gives a sadder sense of decay than this loss or suspension of the power to deal with unaccustomed things, and to keep up with the swiftness of the passing moment. It can merely be a suspended animation; for, were the power actually to perish, there would be little use of immortality. We are less than ghosts, for the time being, whenever this calamity befalls us.

—Hawthorne, 184.

ARTWORKS.

RACHEL FEINSTEIN
Puritan's Delight
2008
Stained wood with electric candle
66.5 x 101 x 91 inches
Courtesy of the artist and Marianne Boesky Gallery, New York

Never before had she had such a sense of intolerable length of time that creeps between dawn and sunset, and of the miserable irksomeness of having aught to do, and of the better wisdom that it would be to lie down at once, in sullen resignation, and let life, and its toils and vexations, trample over one's prostrate body as they may!

—Hawthorne, 79.

ARTWORKS.

BILL CONGER

Endless Night
2006
Candles, masking tape
42 x 1 x 1 inch
Courtesy of the artist

She instinctively knew, it may be, that some sinister or evil potency was now striving to pass her barriers; nor would she decline the contest.

—Hawthorne, 232.

ARTWORKS.

SUE DE BEER
Still from *The Quickening*
Single channel video installation, 27:00 minutes
2006
Courtesy of the artist and Marianne Boesky Gallery, New York

IV.

EXHIBITION VIEWS.

EXHIBITION VIEWS.

THE HOUSE OF THE SEVEN GABLES.

EXHIBITION VIEWS.

EXHIBITION VIEWS.

THE HOUSE OF THE SEVEN GABLES.

EXHIBITION VIEWS.

EXHIBITION VIEWS. 95

V.

EXCERPTS FROM *THE HOUSE REMEMBERS.*

A LONG time ago, I enlisted the camera to explore invisible territories. Some might argue that the camera is not the most appropriate tool for this endeavor, and yet it is the medium through which I can connect with and make sense of this elusive world.... Through the medium of the visible, photography makes the invisible apparent. By collecting extensive evidence of the surface, one becomes aware of what is missing, and a space is provided for the viewer to imagine the invisible.

...

The mid-nineteenth century saw the birth of both photography and the Spiritualist movement in America. The cultural climate was particularly fertile for Spiritualism, because religious beliefs had been thrown into question by science. Spiritualism began in 1848, when three young sisters turned odd rapping noises in their home into a game of spirit communication by asking questions and receiving answers with knocks for "yes" and "no." Adherents of Spiritualism wanted to use science to prove their religious conviction that communication with the dead was possible; thus they enlisted modern technologies, such as the telegraph and camera, to provide "evidence" of the afterlife. In early "spirit photographs," small faces surround the subject. One of the faces would be identified as a dead relative of the subject, and the others were said to be spirit guides. (The use of technology in response to the supernatural continues today, as ghost hunters measure activity with electronic voice phenomena and electromagnetic field detectors.) The majority of Spiritualist mediums (those with the ability to communicate with spirits) were female, and the characteristics associated with successful channeling were the stereotypical feminine attributes of sensitivity and receptivity.

When I photographed in haunted houses, I continued the tradition of female receptivity to the otherworldly: I tried to open myself to the invisible nuances of a space. I listened and attempted to be at its mercy. The particularities of the houses moved me; each demanded an individual response. As the project progressed, my intuitive understanding of where to stand and photograph sharpened. Sometimes I took as few as three images. Studying the interior through the ground glass was an alchemical process that allowed me a heightened experience of my surroundings. The large-format camera transformed my perception and slowed me down. The exposures were usually long, lasting anywhere from a few seconds to a few hours. After opening the shutter I would slip out of the room to wander. I thought of the room as a stage, and I felt there was a greater chance for something to happen in my absence. It was like leaving behind a magic box. As a consequence, when I developed my negatives, I was surprised by images that I had not observed.

Like a souvenir, my photographs are both mute and partial. They are connected to the sites through a story as well as through the indexical nature of photography: the film and the referent were in the same space and time when the image was captured. The philosopher Roland Barthes describes photographic relationships of this sort as an "umbilical cord." In the moment of viewing, the photograph refers simultaneously to *This will be* and *that has been*. This is why photographic representation is linked to death, mortality, and mourning. If they had not been captured, the images and stories in this book would have floated away and vanished into the ether. Yet their concrete permeations are structurally haunted and suspended between reality and fiction: disembodied voices, silent words, the inherent ambiguousness of photographs, and the failure for either words or images to properly elucidate the world.

...

Houses collect impressions of past inhabitants, whether the subtle energy left by occupants, the knowledge of a violent event that occurred there, or the materialization of a ghost. When people move into a house, they commonly try to make it their own by cleaning or renovating it; some burn sage or get a priest's blessing. When they move into houses known to be haunted, people often acknowledge the ghost's right to be there and attempt to make peace with it, saying things like, "We all have to live here together" and "You have a right to be here, but so do I." Some people will not inhabit a haunted house. In 1989, a man purchased a Victorian house in Nyack, New York, that the owner, Helen Ackley, had publicized as haunted. Unfortunately, she did not specifically disclose this information to the buyer. After learning of the haunting, the buyer wanted to back out of the deal and sued for the return of his $32,000 down payment. The appellate court cancelled the contract and ordered a refund of his money. The case highlights the complicated issues surrounding houses, ownership, and ghosts. When we move into a house, we expect to take possession of it, and yet sometimes it has not been fully vacated and our lives become entangled with "other" inhabitants in unexpected ways.

We strive to create the home as a world unto itself. Feeling comfortable and safe in one's home relates to feeling in control. Doors, walls, alarm systems, and gated communities all exist to keep out real and imagined danger. The ghost is an interloper that undermines the notion of the house as private and contained, which is why in horror movies the ghost must be evacuated. Haunted houses are emblematic of Freud's notion of the uncanny, when the security of the home is rendered frightening and unfamiliar by outside forces, repressed events, or memories. These dark, motionless houses secretly drain your energy. People describe feeling depressed and unwell living in these houses and often put off moving in; children are afraid to sleep in their bedrooms, and people blame the house for family strife and bad luck. Many people live in haunted houses—ghost or no ghost—that are marked by abuse and neglect.

...

Similar to ghosts that return home, it is not uncommon for people to return to their childhood home (or houses where they spent formative periods) and ask the current owners for permission to come inside. We walk through these houses as if we are trying to find a lost self or are expecting to bump into our youth. Those who, in the words of Thomas Wolfe, "can't go home again" feed their memory and imagination on nostalgia for their formative spaces. For the author Georges Perec, the loss of a stable home and identity meant that space is constantly negotiated and experienced: "Such places don't exist, and it's because they don't exist that space becomes a question, ceases to be self-evident, ceases to be incorporated, ceases to be appropriated. Space is a doubt: I have constantly to mark it, to designate it. It's never mine, never given to me, I have to conquer it." In a haunted house, unexpected smells, sensations, and forgotten histories arise from beneath the surface of normal life and take hold of us, reminding us that space is an unending negotiation between our phenomenological perception and the outside world. In this sense, we are all haunted.

...

Houses are real and they are not real; they are both a physical space and a mental space full of dreams and desires. The house remembers. It is filled with sorrow, longing, happiness, and love…As you wander through these spaces, you may come into contact with a hidden part of yourself or suddenly "bump into a rememory," as Toni Morrison put it. Haunted houses remind us that, through the spaces we inhabit, our lives intersect with those of others long gone.

We are all subject to the same fate—change and decay, life and death—yet we do what we can to resist oblivion. We build walls and live inside houses, we try to make these interiors as safe and comfortable as possible, we hold our loved ones near. We sometimes wish that we could freeze a particular moment—a lover's embrace, an infant sleeping peacefully—forever. We sweep floors, wash windows, and lock doors. Sometimes the door will not stay shut, and it comes as little surprise that the dead have returned to visit. We are willing to share our homes with ghosts, however, because in the unimaginable future, we hope the door will be open to us, that we will be remembered and invited inside.

—Corinne May Botz is an artist based in Brooklyn. *The House Remembers* appears in her 2010 book *Haunted Houses,* published by The Monacelli Press. *Haunted Houses* is a long-term project for which Botz photographed and collected oral ghost stories in more than 80 haunted sites throughout the United States. These excerpts were selected by Kendra Paitz in consultation with the artist.

VI.

SHALL WE NEVER, NEVER GET RID OF THIS PAST?

And is this what you wanted/
To live in a house that is haunted/
By the ghost of you and me?
– Leonard Cohen, "Is This What You Wanted," 1974

THE EMOTIONAL pain associated with an event doesn't just disappear. It can come back in waves, unexpectedly. When bad things happen to people, and the details are too terrible to comprehend, it can take a long time for the effects of traumatic memory to go away. Grief can be manifest in a persistent ache that lingers for weeks; it can return at the same time each year like a dreaded anniversary or it can be passed down through generations. In popular culture, literature, and cinema the insistent pain attached to the memory of a person or event—something that is both here and not here, distinct yet sitting at the edges of perception—can be described as a haunting, a presence that recalls a traumatic event which cannot be properly integrated and may never be resolved.

Ghosts are the spectral presences of victims and bystanders who linger in the hopes of absolution. The ghost is not an index; it is a sign that an event, a haunting, is occurring. And, if they are anything, ghosts are interruptions. Through their presence and scaring us to death, they insist on being acknowledged and listened to. But this interruption is often difficult to understand because we don't always know the story that the ghost attempts to tell us. What, exactly, has happened and to whom is usually mysterious, clouded in hearsay and conjecture, unverifiable testimonies based on gossip and spurious eyewitnesses.

Mapping the interruption that the ghost performs onto a popular understanding of history, a haunting implies that the past is in a constant negotiation with the present. It asks for the past to be accommodated within the present, that room be made for it. Hauntings open up new possibilities for understanding how the past is proximate, relevant, and, perhaps most importantly, should not be disregarded. A haunting is an affective kind of history that asks us to be skeptical of what we know and how we know it. "Being haunted draws us affectively, sometimes against our will … into the structure of feeling of a reality we come to experience, not as cold knowledge, but as a transformative recognition."[1] Hauntings open up a space outside of the formal parameters of the historical record that accounts for and organizes events and their participants.

Appeals for accommodation and counterclaims of land ownership are the seeds from which many ghost stories develop. Battlefields, borderlands, graveyards and colonies

are fertile grounds with sedimented layers of blood and bones. Still, it is important to remember, "The ghost is not simply a dead or a missing person, but a social figure, and investigating it can lead to that dense site where history and subjectivity make social life."[2] These violent claims of ownership are also often yoked to ethnographic, ideological, theological, and, especially, entrenched sociological struggles that attempt to reify notions of familiarity against, what is perceived to be, a threatening "other."

The land dispute at the core of *The House of the Seven Gables*—in which Colonel Pyncheon's greed led to Matthew Maule being tried and convicted of witchcraft, then publicly executed—is the rotting foundation on which the mansion is built. "What greatly strengthens such a suspicion is the fact that this controversy between two ill-matched antagonists ... remained for years undecided, and came to a close only with the death of the party occupying the disputed soil."[3] As structures that have been built upon the land where the disputes have occurred, historical architectural spaces like the House of the Seven Gables have become containers for an excessive amount of traumatic history. As Hawthorne warns, "His [Colonel Pyncheon's] home would include the home of the dead and buried wizard [Matthew Maule], and would thus afford the ghost of the latter a kind of privilege to haunt its new apartments...."[4] The ground and frames of these old homes have soaked up the festering secrets and residue of family lives, which, in some cases, spill over. And when they do, we can see to what degree, if at all, the living and the dead can share the same space.[5]

In the first season of the FX Network show *American Horror Story*, a young couple moves into a home that is known to everyone but them as "the Murder House." Each episode skips through generations of murders—many that are intended to be familiar episodes in the narrative of American violent crime—that have happened in the house. The house has absorbed but not properly compartmentalized these crimes so the ghosts from each of the murders overlap and occupy the house at the same time; the house is chockablock with successive generations of unruly ghosts. In this way, as Christine Wilson has pointed out, "Haunted house narratives show that possession is always troubled by what, or who, came before. This preoccupation with history and rightful possession forecloses the possibility of ever truly possessing the space in the present."[6] The ghosts have violently competing claims of ownership on the home and the narrative is driven by the failure of these stories to be mingled into (what the producers of the show perceive to be) an American history of haunting. These ghosts are the markers for what has not been properly integrated into a national consciousness.

Hawthorne, like many other writers and artists, uses the haunted house and the narrative revision of traumatic American history to translate actual events into fictional material that can be more easily digested and understood. "In translating history into ghost stories, authors of haunted narratives transform both source and target cultures,

reshaping the past to answer the needs of the present and, implicitly, the future."[7] For example, the battle between Pyncheon and Maule at the beginning of *The House of the Seven Gables* is closely linked to the religious hysteria and summary executions permitted by the Salem Witch Trials of 1692. Colonel Pyncheon wields the same judicial weapons against Maule, "one of those martyrs to that terrible delusion," to secure ownership of the property upon which the mansion is built. It is well known that a member of Hawthorne's family was involved in the Salem trials so *The House of the Seven Gables* can also be read as a way of atoning for the sins of previous generations. Toni Morrison uses a similar technique of translating the history of human slavery in America—also a struggle for ownership—that ignites the traumatic event at the beginning of her fascinating novel, *Beloved*. In it, slave hunters track Sethe, an escaped slave and mother of three children, to the house at 124 Bluestone Road on the outskirts of Cincinnati, Ohio, where she has been hiding. She reacts by starting to methodically kill her children one by one rather than being returned to the Sweet Home plantation where she was enslaved. As grim as it was, and even though she only killed the titular daughter, Beloved, Sethe was forced into this decision; in her mind, it was the last possible resort to prevent her body and her children's lives from being (re)subjugated by slavery. It was a reply to the system of bio-power that controlled her and millions of others so completely.

As an actual house in Salem, Massachusetts, with historical connections to Hawthorne's family and the Salem Witch Trials, the House of the Seven Gables has become a similar site of translation. It has been used, rightly, as a stage for unearthing some of the twisted socioeconomic and theological imbalances of colonial America. There are moments in Hawthorne's book in which the uncanny spaces of the house and the lingering stink of greed and ambition throw into relief the tenuous connection between what we know and "what has happened." Hawthorne explains it this way, "So much of mankind's experience had passed there – so much had been suffered, and something, too, enjoyed – that the very timbers were oozy, as with the moisture of a heart. It was itself like a great human heart, with a life of its own, and full of rich and somber reminiscences."[8] While there is certainly an incorporation occurring in the house, it isn't complete. Matthew Maule's death is unresolved, and because of dying badly, the memory of his death refuses to be located in a grave. Somehow, the house has incorporated Maule's spirit whereby he becomes a 'familiar stranger' that insists on not being forgotten.

The following is one of Hawthorne's narrator's first impressions of the house and it represents an interesting innovation on the narrative trope of haunted houses: "The aspect of the venerable mansion has always affected me like a human countenance, bearing the traces not merely of outward storm and sunshine, but expressive…."[9] Compare this to the opening line of Morrison's *Beloved*, "124 was spiteful. Full of baby's venom," which describes Sethe's refuge as it became a haunted house. In both stories, the house transitions

from being an object to a subject when the frames and structures of the houses have absorbed their viscous histories. It can be imagined that the houses are acting on their own behalf, heaving and sighing with the histories that they contain but also making whatever noises they can to tell, in some way, "what happened here." In these examples, the haunted house is not just a container for bad things that have happened. It is both a subject and a force to be reckoned with. And more than just a structure that functions as a repository for the storage of spectral histories, the house is a building with agency that can stand either for the national consciousness or the individual mind that struggles to integrate traumatic memories. By infusing haunting within an architectural structure, Hawthorne reinforces how space, context, and history create subjectivities, and, in this case, characters who are haunted.

One of the most obvious dilemmas for writing about the visual culture of hauntings and ghosts is that they constantly slip in and out of vision. They are hard to locate. A ghostly presence captured in a photograph should be proof positive that "… it has been here, and yet immediately separated; it has been absolutely, irrefutably present, and yet already deferred."[10] When the ghost has been photographed it has, if for only the shortest of durations, been captured. The early years of photography, when chemical developing was still a mysterious process to most people, must have been a magical time. E.J. Marey and Eadweard Muybridge's fascinating photo experiments froze motion and captured movement that was at the edges of human perception. The camera shutter speed showed people what they were seeing but also what their eyes could not discern. And almost from the moment of its invention, the photograph was closely linked to death. Early photographs, especially daguerreotypes, "typically relate[d] an unexpected discovery, a curio among other discarded mementoes and refuse of a generation past, … ghostlike and ephemeral, yet strangely potent in [their] ability to 'come to life again'"[11] William Mumler's famous spirit photographs, which are now considered and collected as fine art objects, coincided with, and preyed upon, the popular Spiritualism doctrine that denied death and believed in communication with the departed.[12] So, as early as the late 19th century, the camera lens and photographs were technologies that oscillated between supplementing and surpassing human vision, between documents of scientific observation and creative interpretation.

Photography and its relationship to truth telling have changed considerably since *The House of the Seven Gables* was written. In an age of irony and half-truths, of shifting perspectives and "sexed up" evidence, culture has been infused with a persistent sense of skepticism that borders on cynicism. Some artists respond to this general unsettledness with strategic "… exchanges devoted to breaking the forms of enclosure, isolation, limits, and retreat that have recently become the dominant mechanism of political power."[13] Today we "live in an age of 'truthiness,' a time when our understanding of truth may not be bound to empirical evidence – that is, to anything real, provable, or factual."[14]

Holgrave, who shares the House of the Seven Gables with Phoebe, Hepzibah, and Clifford, is a writer, philosopher and daguerreotype artist. He also represents an iconoclastic modern sensibility that eschews the dead weight of the past for the promise of the future. Holgrave's dramatized indignations, such as "Just think a moment, and it will startle you to see what slaves we are to bygone times …"[15] are characterized as naïve and inexperienced "as a tender stripling."[16] Yet they represent the genealogical hypothesis that Hawthorne posits in his introduction, that "Still, there will be a connection with the long past … which, if adequately translated to the reader, would serve to illustrate how much of the old material goes to make up the freshest novelty of human life."[17]

When Holgrave first introduces Phoebe to his daguerreotypes he argues that they are more than images; they provide a view deep into the sitter's character and a look through their postured qualities of leadership and status. He says, "While we give it credit only for depicting the merest surface, it actually brings out the secret character with a truth that no painter would ever venture upon, even could he detect it."[18] Holgrave is making an argument for the democratizing potential of daguerreotypes, a power that can slice through the impasto of commissioned painted portraits. Susan Sontag makes a similar argument, stating, "A photograph is not only an image (as a painting is an image), an interpretation of the real, it is also a trace, something directly stenciled off the real, like a footprint or a death mask … a material vestige of its subject in a way that no painting can be."[19] Holgrave's comments presage the flattening of representation as photographs and photojournalism would grow to increasing prominence in the 20th century. And as Phoebe discovers, Holgrave's hyper-detailed daguerreotype reveals, in spite of his appeals to break with the past, a genealogical link between the Colonel and Judge Pyncheon: "It implied that the weaknesses and defects, the bad passions, the mean tendencies, and the more diseases which lead to crime are handed down from one generation to another …."[20] This presents an interesting paradox for Phoebe: Holgrave's refutation of the past begins to wither with this realization at the same time that she has to acknowledge how the daguerreotype's hyper realistic image can capture genealogical traces that link relatives across generations.

The published highlights from the Stanley B. Burns archive of post-mortem photography, including the famous *Sleeping Beauty* books, have shown how photographs, in ways that may appear macabre to contemporary viewers, were very intimate memorial objects for families of the mid- to late-19th century. Children and parents were often photographed after they died. These photographs were a confrontation with human mortality as well as an affirmation of a person's life and the bonds they shared, a visual embalming, with their dead body surrounded by mourning family members.[21] Post-mortem photographs represent the deepest affirmation of love one can have for another person; it's the kind of love that can only be understood by and through loss.

When Holgrave shows Phoebe his post-mortem daguerreotype of Judge

Pyncheon, she knows, immediately, what she is looking at, "This is death! Judge Pyncheon is dead!"[22] In trying to assimilate this moment, Phoebe's frightened response, "derives from the fact that both share a similar structural relation with the person from whom they originate...."[23] The image is a hyperreal likeness of the Judge but it is only the shell, a mere remnant of the person. "The daguerreotype as a technology of perception creates a new form of surveillance and documentation that would heal the world of the fathers who have abused their power through its private enclaves."[24] For Holgrave, there is validation in capturing the Judge's dead body so that he can reveal the deceased's misdeeds and manipulations of the political process.

The practice of post-mortem photography has evolved over the years. Because of changing social attitudes towards death, not to mention medical innovations, we are no longer so close to the dead bodies of friends or relatives. After the World Trade Center tragedy of 2001 and the wars in Iraq and Afghanistan, we are more likely to see temporary yet public forms of photographic memorial than post-mortem photographs. The photograph is a remnant, barely a ruin, which captures a moment or a life that has passed. But violence persists and images from the battlefield have become weapons for promoting revolutionary agendas, swaying public opinion, and marking the end of a regime.[25] All of this has lead to debates about distributing wartime images, including how photographs of soldiers' coffins should be published in the news media.[26]

Whether we see death as a result of war or natural disasters, "the photograph tells us we will die, one day we will no longer be here, or rather, we will only be here the way we have always been here, as images."[27] For families of victims, these memorials are a way to articulate their personal grief and loss through an attachment to historical events. But for all of us, they are a prompt to remember that "Photography, like ghosts, can sometimes, though it does not always, insist that you remember history and consider, however briefly, and even if only affectively, your own relation to history and those who proceed you or exist in other places."[28]

Shortly after a massive clothing factory collapsed in Dhaka, Bangladesh, on April 24, 2013, rescue workers rushed to the scene to begin removing the hundreds of bodies that were buried under the rubble. The number of dead grew steadily as the recovery mission proceeded and it became the worst manufacturing disaster in history. On April 25, photojournalist Taslima Akhter captured the image that would come to represent this disaster. "Around 2am, I found a couple embracing each other in the rubble. The lower parts of their bodies were buried under the concrete. ... it haunts me. It's as if they are saying ... *We are human beings like you. Our life is precious like yours, and our dreams are precious too.*"[29] The photo is a remnant of an event, but through its affective power, it creates a haunting connection that is hard to let go. Akhter's photo is a document of people who have been killed by a specific event; what makes it so uncanny is that their embrace is the same in death as it would have been in life. But it's also so much more than a

documentary photo. This dead couple succinctly encapsulates a moment that has become another traumatic instance in the history of an exploited labor force; it ensures that when people see this photo they will never lose contact with what happened in Dhaka. If we don't allow ourselves to be interrupted by ghosts, and aren't open to being haunted by the memory of something, we are likely to forget them.

—Christopher Atkins is a Curator and Coordinator of the Minneapolis Artists Exhibition Program at Minneapolis Institute of Arts.

The title of this essay quotes Holgrave's character in Chapter XII of *The House of the Seven Gables*.
1. Avery F. Gordon. *Ghostly Matters: Haunting and the Sociological Imagination*. Minneapolis: University of Minnesota Press, 1997: 8.
2. Gordon, 8.
3. Nathaniel Hawthorne. *The House of the Seven Gables*. New York: Bantam Classics, 2007: 7-8. iBooks edition.
4. Hawthorne, 8.
5. "The point is neither for the living to exorcize the dead nor for the dead to frighten away the living, but to find a means of coexistence." From Colin Davis, "The Skeptical Ghost: Alejandro Amenábar's 'The Others' and the Return of the Dead," in *Popular Ghosts: The Haunted Spaces of Everyday Culture*, edited by María del Pilar Blanco and Esther Peeren, 67. London: Continuum, 2010.
6. Christine Wilson. "Haunted Habitability: Wilderness and American Haunted House Narratives," in *Popular Ghosts: The Haunted Spaces of Everyday Culture*, edited by María del Pilar Blanco and Esther Peeren, 209. London: Continuum, 2010.
7. Kathleen Brogan. *Cultural Haunting: Ghosts and Ethnicity in Recent American Literature*. Charlottesville: University of Virginia Press, 1998: 11.
8. Hawthorne, 19.
9. Hawthorne, 6.
10. Roland Barthes. *Camera Lucida*. Translated by Richard Howard. London: Verso, 2000 [1981]: 77.
11. Susan Bruce. "Sympathy For the Dead: (G)hosts, Hostilities and Mediums in Alejandro Amenábar's 'The Others' and Postmortem Photography." Discourse, Vol. 27, No. 2/3, Hostly and Unhostly Mediums (Spring and Summer 2005): 30.
12. See Louis Kaplan, *The Strange Case of William Mumler: Spirit Photographer*. Minneapolis: University of Minnesota Press, 2008.
13. Okwui Enwezor, ed. "The Unhomely: Phantom Scenes in Global Society," in *The Unhomely: 2nd International Biennial of Contemporary Art of Seville*. Exhibition catalog. Fundación BIACS: Seville, 2006: 14.
14. Elizabeth Armstrong, "On the Border of the Real," in *More Real?: Art in the Age of Truthiness*. Exhibition catalog. New York: Prestel, 2013: 34.
15. Hawthorne, 113.
16. Hawthorne, 111.
17. Hawthorne, 7.
18. Hawthorne, 60.
19. Susan Sontag. *On Photography*. New York: Penguin, 1979: 154.
20. Hawthorne, 77.
21. Stanley B. Burns, M.D., with Elizabeth A. Burns. *Sleeping Beauty II: Grief, Bereavement, and the Family in Memorial Photography. American and European Traditions*. New York: Burns Archive Press, 2002: Preface.
22. Hawthorne, 189.
23. Bruce, 26.
24. Joan Burbick. *Healing the Republic: The Language of Health and the Culture of Nationalism*. London: Cambridge University Press, 1994: 299.
25. Andrew Malone. "Libya's most gruesome tourist attraction: Our man comes face-to-face with Gaddafi's battered and bloodied corpse," *The Daily Mail*, October 24, 2011. http://www.dailymail.co.uk/news/article-2052777/Gaddafi-dead-body-picture-Libyas-gruesome-tourist-attraction.html#ixzz2UVytrn7I.
26. Elisabeth Bumiller. "Pentagon to Allow Photos of Soldiers' Coffins," *New York Times*, February 23, 2009. http://www.nytimes.com/2009/02/26/us/26web-coffins.html?_r=0
27. Eduardo Cadava. *Words of Light: Theses on the Photography of History*. Princeton: Princeton University Press, 1997 (quoted in Bruce, 27).
28. Bruce, 36.
29. "A Final Embrace: The Most Haunting Photograph from Bangladesh," *Time*, May 8, 2013. http://lightbox.time.com/2013/05/08/a-final-embrace-the-most-haunting-photograph-from-bangladesh/#1.

VII.

SYNOPSIS OF MAJOR CHARACTERS.

COLONEL PYNCHEON
Colonel Pyncheon is the wealthy Puritan patriarch of the Pyncheon family. He acquires the land on which he builds his home, the House of the Seven Gables, by accusing the current landowner, Matthew Maule, of witchcraft. Pyncheon dies in his new home on the day of his house-warming party, but the repercussions of his devious act haunt the subsequent generations of his family.

MATTHEW MAULE
Matthew Maule, the patriarch of the Maule family, is accused by Colonel Pyncheon of practicing witchcraft. As he is about to be hanged from the gallows, he points to Pyncheon and curses him and his descendants, proclaiming "God will give him blood to drink." Maule family members possess mesmeric powers and are reported to have an "evil eye."

HEPZIBAH PYNCHEON
Hepzibah Pyncheon is a member of the current generation of Pyncheons, "two centuries" removed from Colonel Pyncheon. She is a reclusive, middle-aged woman who lives in the House of the Seven Gables. Because the family is no longer wealthy, she opens a dime store in the house and rents a room to a boarder, Holgrave. She pines away for her beloved brother, Clifford, during his extended imprisonment and cares for him upon his release.

CLIFFORD PYNCHEON
Clifford Pyncheon, Hepzibah's brother, spends thirty years in prison after his cousin, Judge Pyncheon, frames him for the murder of a family member. Clifford is timid and childlike upon his return to the family home but he responds to beauty, particularly fresh flowers. Hepzibah and Phoebe, a young cousin, diligently care for him.

JUDGE JAFFREY PYNCHEON
Judge Pyncheon is the manifestation of Colonel Pyncheon in the current generation. A cousin to Hepzibah and Clifford, he expresses no remorse for his role in the latter's wrongful incarceration. He greedily accumulates wealth and power and is expected to be named as his party's candidate for Governor of Massachusetts until he, like his predecessor, dies suddenly in the house.

PHOEBE PYNCHEON
Phoebe Pyncheon is Hepzibah and Clifford's young "country cousin." Because she has been raised apart from the rest of the Pyncheons, she brings a fresh perspective and cheerful demeanor when she comes to the House of the Seven Gables. She assists with Clifford's care and develops a relationship with Holgrave.

HOLGRAVE
Holgrave is the daguerreotypist to whom Hepzibah rents a room in the house. He is an artist who embraces democratic ideals and new technologies. His photographs ultimately reveal Judge Pyncheon's hidden character and help resolve a family mystery. A descendant of the Maule family, he also possesses mesmeric powers.

ALICE PYNCHEON
Alice Pyncheon is a family member from an earlier generation, who, like Phoebe, was raised outside the house and was able to maintain a lighthearted presence. Because of his greed for more property, Alice's father allowed her to be mesmerized by a Maule and she never recovered. Alice's memory is evoked through the flowers she planted and strains of the music she played.

VIII.

ACKNOWLEDGEMENTS.

THE concept of a haunted house, in its various cultural manifestations, has fascinated me since childhood. Reading Nathaniel Hawthorne's *The House of the Seven Gables* inspired me to engage with artists who critically explore how the residue of the past seeps into the present. This exhibition and catalogue—the culmination of an idea I had been thinking about for nearly four years before the show was actually realized—are my attempt to both visually interpret a canonical work of American literature and to productively structure a project that explores the disquietude of memories and unraveling of histories that are so integral to a "haunting." First and foremost, I am so grateful to the artists for their generosity and enthusiasm: Reed Barrow, Corinne May Botz, Jan Bünnig, Anne Collier, Bill Conger, Drew Conrad, Sue de Beer, Rachel Feinstein, Andreas Fischer, Anya Gallaccio, Benjamin Gardner, Katy Grannan, Alice Hargrave, Bob Jones, Brian Kapernekas, Rachel Khedoori, Peter Krashes, Jacco Olivier, Robert Overby, Dario Robleto, Gregor Schneider, and Sarah E. Wood. I offer special thanks to Dario Robleto and Corinne May Botz for providing fascinating and thoughtful public lectures during the exhibition.

I express my gratitude to the collectors who kindly loaned work to the exhibition, including Steve Williams and Heidi O'Neill, and Robin Wright and Ian Reeves. Staff members at the following galleries and studios played instrumental roles in coordinating logistics and securing the loans of artworks: Bill Gross at 65GRAND, Chicago; Randy Sommer at ACME., Los Angeles; Bonni Benrubi, New York; Adrian Turner, Veronica Levitt, Ricky Manne, Elizabeth Miseo, Taylor Trabulus, and Annie Rana at Marianne Boesky Gallery, New York; Luis Campaña and Marie Klooker at Galerie Luis Campaña, Berlin; Maureen Sarro, Natalia Hayeem, and Winslow Smith at Fitzroy Gallery, New York; Jessica Green, Sara Harrison, and Maria Brassel at Hauser & Wirth, London; Patrick Reynolds and Kerry Inman at Inman Gallery, Houston; Courtney Treut and Jenny Gerozissis at Anton Kern Gallery, New York; Ephraim Puusemp at Rachel Khedoori Studio; Stephanie Smith, Vanessa Caldas, and Amy Cosier at Lehmann Maupin, New York; Linda Burnham, Marquita Flowers, and Nicole Emanuel at Robert Overby Studio; Alissa Friedman at Salon 94, New York; Alisun Woolery, Joshua Holzmann, and Marc Selwyn at Marc Selwyn Fine Art, Los Angeles; and Kate Werble and Jody Graf at Kate Werble Gallery, New York. Additionally, Tabor Story at Gladstone Gallery, New York; Andrew Kreps at Andrew Kreps Gallery, New York; and Charlotte Marra at Rhona Hoffman Gallery, Chicago, provided valuable assistance with securing contact information.

The staff at University Galleries was endlessly supportive in embracing this project in all stages. I would like to thank Barry Blinderman, Director, for consistently trusting me to realize my curatorial visions and for critically proofreading and editing my texts; Tony Preston-Schreck, Curator and Interpretive Programs Coordinator, for developing meaningful educational and exhibition opportunities for high school students related to the project and adeptly installing many of the artworks; and Gabriel Johnson, Registrar, for graciously coordinating all the loans and shipping of artwork and designing a beautiful exhibition announcement. Additionally, the following University Galleries' student workers, interns and graduate students worked tirelessly to install the exhibition

and assist in the related educational programming: Jace Battrell, Alyssa Bralower, Dan Brzeznick, Claire Frederick, Tessa Gillett, Jeri Kelly, Jacki Major, Karolina Ogorek, Kyle Riley, Gina Tabascio, and Lucien Winner. Tricia Clar skillfully designed the catalogue cover and gracefully assisted with streamlining the catalogue design.

I am fortunate to work in a university where so many people are excited to work together on projects. I appreciate Susan Kalter's very early support of this idea, long before it was fully developed. Without her initial encouragement, this exhibition might never have come to fruition. As always, the staff at Illinois State University's Milner Library was supportive from the first moment I approached them about collaborating on outreach programming: Kathleen Lonbom, Maureen Brunsdale, Andrew Huot, and Dane Ward. Art historian Melissa Johnson, along with students Marissa Webb and Samantha Simpson, curated a stunning satellite exhibition of daguerreotypes and provided a thought-provoking lecture on daguerrean vision. Brian Rejack generously led one of the public reading groups, consisting primarily of students who were encountering Hawthorne's book for the first time. Sonja Moser developed an ambitious assignment for the students in her 340 Directing Workshop class in Devised Theatre. It was a great pleasure to work with her and her students as they created their own public performances inspired by *The House of the Seven Gables*. Jean MacDonald offered useful ideas and helpfully assisted in promoting the exhibition. I greatly appreciate Alex Hogan's striking photographs of the exhibition. The staff at Research and Sponsored Programs and the College of Fine Arts Dean's Office staff, particularly Janis Swanton and Laurie Merriman, have very ably supported our continued efforts to secure funding. Eric Yeager, Jason Tuchholke, and Greg Swank provided continual assistance with much needed technology and equipment needs. Jen Kaczmierck and Dan Browder offered necessary installation materials from the School of Theatre's prop shop.

I thank Bill Kemp at the McLean County History Museum for supporting research for the concurrent daguerreotype exhibition, and for lending materials from the museum's collection. I am grateful to Rebecca Filner and Anne Garner at the New York Public Library's Berg Collection for enabling my research visit. I appreciate Brian Simpson at Babbitt's Books for his assistance in promoting the project. Julian Antos provided a desperately needed film looper.

I am so grateful to Christopher Atkins, Justine S. Murison, and Corinne May Botz for their early embrace of this exhibition and for their intelligent essays. I thank Elizabeth White at Monacelli Press for authorizing the inclusion of excerpts from Botz's previously published essay. Thank you to Tiffany Chatham-Smith at Regent Publishing Services.

This project would not have been possible without the generous exhibition and publication support provided by The Andy Warhol Foundation for the Visual Arts and a pivotal publication award from the Elizabeth Firestone Graham Foundation. I am thoroughly indebted to them for providing the critical funding necessary to realize the exhibition, catalogue, and related programming.

Lastly, I thank Ryan and Mia Paitz, the loves of my life, who have been by my side through every step of this project.

—Kendra Paitz, Curator of Exhibitions, University Galleries of Illinois State University

IX.

EVENTS.

THE HOUSE OF THE SEVEN GABLES.
Curated by Kendra Paitz
On view at University Galleries of Illinois State University from February 23 - April 7, 2013
Opening reception: February 23, from 5-7 pm

ARTIST LECTURE BY CORINNE MAY BOTZ.
February 23, 2013, at 4 pm at University Galleries

A MOMENT THAT FLITS AWAY: DAGUERREAN VISION IN NATHANIEL HAWTHORNE'S THE HOUSE OF THE SEVEN GABLES.
On view at Illinois State University's Milner Library from February 23 - April 7, 2013
Curated by Melissa Johnson, with assistance from Marissa Webb and Samantha Simpson

NATHANIEL HAWTHORNE IN MILNER LIBRARY'S SPECIAL COLLECTIONS.
On view at Milner Library from February 23 - April 7, 2013
Organized by Maureen Brunsdale

EDUCATOR WORKSHOP: THE ART OF BOOKMAKING.
February 25, 2013, at 5 pm at University Galleries
Led by Andrew Huot

GALLERY WALK WITH EXHIBITION CURATOR KENDRA PAITZ.
March 6, 2013, at 5:30 pm at University Galleries

ARTIST LECTURE BY DARIO ROBLETO.
March 20, 2013, at 12 pm at University Galleries

PHOTOGRAPHY HISTORY LECTURE BY MELISSA JOHNSON.
April 1, 2013, at 4 pm at Milner Library

DEVISED PERFORMANCE AND *THE HOUSE OF THE SEVEN GABLES.*
Performances created and performed by the 340 Directing Workshop class in Devised Theater
April 2, 2013, at 12 pm, and April 4, 2013, at 4 pm, in Williams Hall (an Illinois State University building allegedly haunted by the school's first librarian, Angeline Milner). Led by Sonja Moser

READING GROUPS AND CURATOR-LED TOURS.
Ongoing throughout the duration of the exhibition

WORKSHOPS FOR HIGH SCHOOL STUDENTS.
Ongoing throughout the duration of the exhibition
Organized and led by Tony Preston-Schreck and Jeri Kelly

X.

CREDITS.

© 2014 University Galleries of Illinois State University. All rights reserved.
© 2014 Justine S. Murison, "Art, History, and Haunted Houses: Nathaniel Hawthorne's *The House of the Seven Gables*."
© 2014 Kendra Paitz, "We Live in Dead Men's Houses."
© 2010 The Monacelli Press, New York, New York. Corinne May Botz, "Excerpts from *The House Remembers*."
© 2014 Christopher Atkins, "Shall we never, never get rid of this Past?"
All reproductions of artwork © the artists and courtesy of the artists, collectors, and galleries.

Publisher: University Galleries of Illinois State University, Normal, Illinois
Editor: Kendra Paitz
Editorial assistance and proofreading: Barry Blinderman
Design: Kendra Paitz, with assistance from Tricia Clar
Cover design: Tricia Clar
Printer: Regent Publishing Services, San Diego, California
Distributor: Distributed Arts Publishers, New York, New York www.artbook.com
ISBN: 978-0-945558-25-5
Photo credits: Alex Hogan: 41, 45, 47, 49, 53, 61, 67, 69, 73, 75, 77, 83, 86-88, 90-93; Bill Orcutt: 57; Kendra Paitz: 79, 89, 94; Robert Wedemeyer: 39.

This catalogue was published in conjunction with the exhibition *The House of the Seven Gables*, curated by Kendra Paitz, and presented at University Galleries of Illinois State University from February 23 through April 7, 2013. The publication's design was inspired by studying the visual identity of the first edition of Nathaniel Hawthorne's *The House of the Seven Gables*.

This exhibition and publication have been made possible by a critical grant from The Andy Warhol Foundation for the Visual Arts. The Elizabeth Firestone Graham Foundation provided generous support for the catalogue. Programs at University Galleries are supported in part by a grant from the Illinois Arts Council, a state agency.

university galleries
illinois state university
college of fine arts

110 center for the visual arts
campus box 5600
normal, il 61790-5600
tel 309.438.5487
email gallery@ilstu.edu
www.finearts.illinoisstate.edu/galleries
www.facebook.com/universitygalleries

Illinois Arts Council

ILLINOIS STATE UNIVERSITY

...but in old houses like this, you know, dead people are very apt to come back again!

—Hawthorne, 89.

THE END.